Chasing Bright Medusas

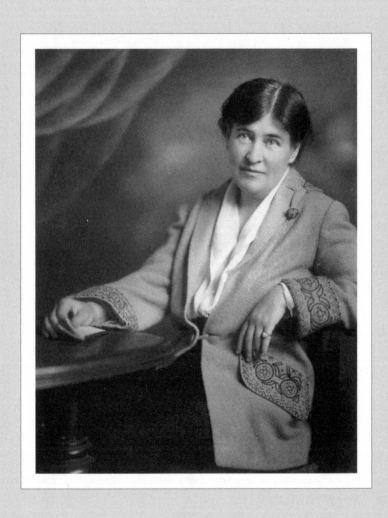

Chasing Bright Medusas

A Life of Willa Cather

Benjamin Taylor

VIKING

VIKING

An imprint of Penguin Random House LLC

penguinrandomhouse.com

Frontispiece: PHO-4-W689-766. Willa Cather Pioneer Memorial Collection.
Willa Cather Foundation

Image credits may be found on pages 173–74.

LIBRARY OF CONGRESS CATALOGING-IN-PUBLICATION DATA

Names: Taylor, Benjamin, 1952– author.

Title: Chasing bright medusas : a life of Willa Cather / Benjamin Taylor.

Description: [New York] : Viking, [2023] |
Includes bibliographical references and index. |

Identifiers: LCCN 2023005009 (print) | LCCN 2023005010 (ebook) |
ISBN 9780593298824 (hardcover) | ISBN 9780593298831 (ebook)

Subjects: LCSH: Cather, Willa, 1873–1947. | Women novelists,
American—Biography.

Classification: LCC PS3505.A87 Z867 2023 (print) | LCC PS3505.A87 (ebook) |
DDC 813/.52 [B] —dc23/eng/20230607

LC record available at https://lccn.loc.gov/2023005009

LC ebook record available at https://lccn.loc.gov/2023005010

Printed in the United States of America

3 5 7 9 10 8 6 4 2

DESIGNED BY MEIGHAN CAVANAUGH

To my family

The unexpected favors of fortune, no matter how dazzling, do not mean very much to us. They may excite or divert us for a time, but when we look back, the only things we cherish are those which in some way met our original want; the desire which is formed in early youth, undirected, and of its own accord.

—*The Song of the Lark*

If there were an instrument by which to measure desire, one could foretell achievement.

—*The Professor's House*

Contents

⸺◆⸺

Chasing Bright Medusas

Prologue

————◆————

She was christened Wilella Cather, but the name displeased her and she tried out, in childhood, various modifications: Willa Love Cather, William Cather, M.D., William Cather, Jr., and then, at twenty-eight, Willa Sibert Cather, which stuck till 1920. She was her own raw material and self-transformation was her game. The writer who leapt into the forefront of American letters with *O Pioneers!* (1913), *The Song of the Lark* (1915), and *My Ántonia* (1918) was already middle-aged, and had generated hundreds of thousands of words of journalism, copy she regarded as a closed chapter of her life after 1912 and wished never to speak about. Slow

emergence—by way of theater and book reviews and human-interest features at the *Nebraska State Journal*, Lincoln's leading newspaper, then as an editor and contributor at the *Home Monthly* in Pittsburgh (a would-be competitor to the *Ladies' Home Journal*), then teaching at two Pittsburgh high schools, then as managing editor and contributor at an important muckraking periodical, *McClure's Magazine*, in New York—did not deter her from the ultimate goal, which was literary immortality. Writing to her friend Mariel Gere in August 1896, she said: "There is no God but one God and Art is his revealer. That's my creed and I'll follow it to the end, to a hotter place than Pittsburgh if need be."

Her story begins in Virginia's Shenandoah Valley, in the town of Winchester, where she lived until the age of nine (and whose native speech she seems to have preserved traces of all her life). She was exposed early by her maternal grandmother to the Bible, *The Pilgrim's Progress*, and *Peter Parley's Universal History*. When she was nine a reversal of the family's never-very-stable fortunes induced her father to try his luck in the West. They settled in Nebraska, on the high plains between the Little Blue and Republican Rivers near a town called Red Cloud. The bare-as-sheet-iron landscape was at first frightening. James Burden surely speaks for Willa's nine-year-old self when he says in *My Ántonia*: "There was nothing but land: not a country at all, but the material out of which

countries are made . . . I had never before looked up at the sky when there was not a familiar mountain range against it."

Red Cloud and environs would prove the abundant seed-bed of her imagination, and granted her a kind of exposure she could never have had in the Shenandoah Valley. A few doors down in Red Cloud were the Weiners, a Jewish couple (vividly captured as the Rosens in "Old Mrs. Harris") whose paintings and library and collection of Victrola records were a first taste of contemporary arts and letters. There was William Ducker, a store clerk with whom Willa studied Latin and Greek, advancing far enough to read Homer, Virgil, and Ovid.

More profoundly, there were Swedes, Czechs, Norwegians, Russians, French Canadians, Mexicans, and more on the sparsely settled plains. She heard a babel of languages and observed ways of life very different from her own. These deep influences made her a cosmopolitan while she was still a provincial. They seem one key to her deeper theme: the nation as a gathering of peoples from elsewhere, adding Americanness to some earlier identity—as in her favorite book, *The Aeneid*, Aeneas founds Rome, thereby adding an Italic identity to his Trojan origins; as she herself added a Midwestern identity to the Virginian self she began with. I find this grafting of later onto earlier the central trope in her work—and the transformations of westwardness and escape from old trammels her chief theme. As she puts it in *The Song of the Lark*, the United

States is "a place where refugees from old, sad countries were given another chance." Her books are in effect a critique of Frederick Jackson Turner's famous and outmoded frontier thesis: Turner has little to say about the disproportionate number of immigrants defining the westward movement of the nation.

What sets her apart from her younger contemporaries—Hemingway, Faulkner, Fitzgerald, Dos Passos—is that this idealism about American possibility was unironic. What makes her the greatest of anti-modernists is that *ideals* were what were most real to her. In *The Song of the Lark* she calls them "instinctive standards for which one is bound to suffer." Compare the authors of *The Sun Also Rises*, *The Sound and the Fury*, *The Great Gatsby*, and *Manhattan Transfer*, men who wrote mockingly about the illusoriness and deceptiveness of ideals. To Alfred Knopf she would declare in 1932: "If all the great 'loyalties' are utter lies—why then, they are ever so much better than the truth. And that is what brought ideals out of the dung heap in the first place—because creatures weren't content with dung, though it is always there and in a sense more 'real.'"

"All my stories," she told a Nebraska journalist, "have been written with the material that was gathered—no, God save us! Not gathered but absorbed—before I was fifteen years old." There's truth in this, of course. Temperament is established early and does not change. But what is most strik-

ing about Cather's life is the catalytic role of experience on temperament. It was an ever-expanding knowledge of the world that would propel her to greatness. At twenty-five she spent an unforgettable week in New York, visiting museums and galleries, attending the Metropolitan Opera, writing reviews of plays for the New York *Sun*, lunching with Helena Modjeska, the great Polish actress. At twenty-nine she visited Europe for the first time: London and the west of England, Paris, Marseille, the cities and towns of Provence.

Momentous, yes. But of still greater import would be a 1912 journey to Winslow, Arizona, to visit her brother Douglass. She was captured for good and all by the harsh beauty of the Southwest—"hard bit by new ideas," as she called it in a letter to her young friend Elizabeth Shepley Sergeant. It seemed to her the landscape of an inner life hitherto unknown. Here she first became aware of eleventh- and twelfth-century Anasazi ruins honeycombing the canyons and mesas. As she writes to S. S. McClure: "I feel as if my mind had been freshly washed and ironed, and were ready for a new life." Three years later she returned to the Southwest with Edith Lewis—the companion with whom she'd spend close on half a century—for an ecstatic summer-long stay. ("Happiness is something one can't explain," Tom Outland will say in *The Professor's House*, remembering his months on the mesa. "Troubles enough came afterward, but there was that summer, high and blue, a life in

itself.") In addition to Mesa Verde, her inspiration for the Tom Outland inset (a glorious novella in its own right), they visited Taos and Santa Fe, both of which would prove crucial to her later work.

With that 1915 trip, the mold of her life was set. She was deep into middle age: forty-one. She had followed, as she calls it in "Old Mrs. Harris," "the long road that leads to things unguessed at and unforeseeable." She did not make of herself a myth, as had Whitman and Frost. Her life does not have the beautiful or dire shape of parable, like Emily Dickinson's or Hart Crane's (or Hemingway's, for that matter). She was bedeviled by neither mental illness nor alcoholism nor any other occupational hazard. She grew to hate most of modernity, declaring in 1936 in a famous adage, that "the world broke in two in 1922 or thereabouts," and that she belonged to the severed past. Perhaps not surprisingly, her later work reached back deeper and deeper into history, to the early French settlers of Quebec in *Shadows on the Rock*, to slaveholding Virginians in *Sapphira and the Slave Girl*. At the end of her life she was at work on a long story or perhaps a novel meant to take place in fourteenth-century Avignon.

How to dramatize the slow, steady fire she was? All scholars of Cather are indebted to Edith Lewis's *Willa Cather Living: A Personal Record* and Elizabeth Shepley Sergeant's *Willa Cather: A Memoir*, both from 1953. Also from 1953 is Edward

Killoran Brown's *Willa Cather*, the first biography. Two additional biographies on the shelf are noteworthy. There is, from 1987, *Willa Cather: A Literary Life* by James Woodress, a vast tabulation of the data. And there is Sharon O'Brien's *Willa Cather: The Emerging Voice*, from 1986, which covers only the first half of the life.

As well, Cather has been lucky in the critics she's attracted, particularly Hermione Lee, whose *Willa Cather: Double Lives* remains the best single book. Also worthwhile is Joan Acocella's witty, spirited excursion into the world of Cather studies, *Willa Cather and the Politics of Criticism*.

Lee and Acocella simply take Cather's strong preference for her own gender as a given, much as Cather herself seems to have done. And they are both good at revealing how effortlessly androgynous she was in her imagination. (But is androgynous imagination not a feature of all the most cherished novelists—Emily Brontë, Dickens, George Eliot, Tolstoy, Proust, and so on? They effortlessly inhabit the skins of men and women characters.)

These earlier Cather scholars were obliged to paraphrase letters, never quote from them. But paraphrase is a poor substitute for Cather's stylistic verve. The letters are an unmediated channel to her inner life. With the lifting at last of this stricture against quoting from them, the time has come for a new biography. I wish to frame the story as driven by Cather's

antagonism to the times in which she lived. She alone among the moderns wrote with unguarded admiration about the antique virtues: valor, loyalty, fulfillment of some high destiny. I think of two of her most memorable heroes, Professor Godfrey St. Peter in *The Professor's House* and Father Latour in *Death Comes for the Archbishop*, men so triumphant at journey's end as to call to mind Shakespeare's hero estranged from his times, Prospero. Professor St. Peter, the famed and prematurely aged historian, reacquaints himself, after long neglect, with the original, unmodified Godfrey, the boy he was and whom he now feels to have been most real in his sequence of selves. By contrast, Father Jean Marie Latour in *Death Comes for the Archbishop* experiences, in the shadow of death, a simultaneity of all the Jean Maries he's been, all of them now on an equal footing: "He sat in the middle of his own consciousness; none of his former states of mind were lost or outgrown. They were all within reach of his hand, and all comprehensible."

Cather's genius, unmistakable from 1913, was belated. While her life was luckier than her contemporary Proust's—he died at fifty-one, she at seventy-three—both vanquished lesser selves along the rough path to fulfillment of their aims. Both became geniuses through traceable feats of will. (Cather writes to her friend Elizabeth Shepley Sergeant: "If only I could nail

up the front door and live in a mess, I could simply become a fountain pen and have done with it.—a conduit for ink to run through. And I like that well enough, too. I'm less trouble to myself than I am at any other time.") She found herself more and more truly as she wrote.

Richard Holmes, dean of contemporary British biographers, says: "The dead call to us out of the past. They ask to be heard, remembered, understood." Who doubts it? The right distance, the right judgment, the right angle of vision— these bring a heroine or hero to life on the page. Holmes speaks of "the infinitely puzzling difference between chance and destiny in biographical narrative: between the contingent and the inevitable, between the phrase 'and then . . . ' and the phrase 'and because . . . '"

In the case of Cather, the protagonist is from an early age driven by an inevitability or exalted sense of who she was fated to be; she is determined not to get ambushed by contingencies—as if she resolved in childhood that she would get everything out of life she wanted. The pitfalls were for others. She believed in luck, particularly her own, and believed in the luck-making power of desire. She had a destiny, devoutly believed in; she swept aside impediments; her goals were vividly before her.

A chain of influence runs from Cather to Katherine Anne

Porter, from Porter to Eudora Welty, from Welty to Alice Munro. These three venerated her. Munro's story "Dulse" tells of a Mr. Stanley so besotted by Willa Cather that his joy in life is to come to Grand Manan Island in the Bay of Fundy—thirty-five miles off the New Brunswick coast—where Cather spent many summers, and sit in a folding chair beside her cottage, gazing out, imagining what Willa's view of the Atlantic would have been before the trees obscured it. These pilgrimages arise from a debt of love: "'I have been her admirer for over sixty years,' he said. He paused, holding his knife over his plate. 'I read and reread her, and my admiration grows. It simply grows. There are people here who remember her. Tonight, I am going to see a woman, a woman who knew Willa, and had conversations with her. She is eighty-eight years old but they say she has not forgotten. The people here are beginning to learn of my interest and they will remember someone like this and put me in touch.'"

I own to a feeling of fraternity with Mr. Stanley. "What a lovely, durable shelter he had made for himself," writes Munro. "He could carry it everywhere and nobody could interfere with it." So Cather has been, for me—a lovely, durable shelter. This book arises from a debt of love.

One

To a Desert Place

The beautiful word "Shenandoah," of unknown Native American origin, stands for a river and an opulently green valley. Willa Cather's Virginia forebears on both sides had been there for four generations. Winchester township, seat of Frederick County, lies along the old turnpike between North and South and repeatedly changed hands in the course of the Civil War. Willa's grandfather William Cather, of Welsh ancestry, had stayed resolutely Unionist. Her mother's people, the Boaks, were secessionists. Her uncle William Seibert Boak had died of his wounds at Manassas. Willa's mother, Virginia Boak Cather, revered the memory of this nineteen-year-old,

her favorite brother, and kept his saber and Confederate flag with her always.

In *Sapphira and the Slave Girl* (1940), Cather's final novel, published seven years prior to her death, she re-created the antebellum world of her grandparents. The setting is Back Creek, where her mother's people, the Boaks (Blakes in the novel), had been long settled. The year of the novel is 1856. Sapphira Dodderidge Colbert, a dropsical invalid, fears that her husband, Henry, is on the verge of having an affair with their "half-caste" housemaid, Nancy, and wishes to sell the girl. Sapphira's adult daughter—the warmhearted heroine of this otherwise chilly book—arranges for Nancy to escape across the Potomac and on to Canada via the underground railroad.

There is substance to Toni Morrison's objection that the novel submits its Black heroine to the white gaze of the Colberts; she is understood only from without. Yet in the end it is she, the slave girl, and Till, her mother—subject to the barbarity of the peculiar institution—who emerge as the only unmarred persons in the book. The moral mutilation of having owned chattel persists among the whites, an indelible sin.

In the epilogue Nancy returns decades later to visit her former owners. Just such a visitation was among Willa's earliest memories. It is as though she had all along been treasuring it up for last. "In this book my end was my beginning," she

wrote to Alexander Woollcott. What she knew during the first nine years of life was Back Creek and its environs and nothing beyond. The return of Nancy must have seemed to the little girl a visionary event.

Edith Lewis felt *Sapphira* had been catalyzed by the deaths of Charles Cather, her father, and, three years later, her mother, Virginia Boak Cather. In relative old age Willa brought all powers to bear on her remotest family recollections, the scenes of early childhood. The valley of the Shenandoah, little on her mind for decades, grew luminous.

Lands west of the Missouri were a strong lure for Virginians in the aftermath of the Civil War. Congress had passed the Homestead Act in 1862; if you were white and male there was land for the taking. As Woodress writes: "A man could plow a straight furrow as far as the horizon, and the rich top soil was said to be twelve feet deep." This idealism would come up against the unforgiving reality of heat waves cooking the corn in its tassel, grasshopper invasions, howling winters—and the fundamental obduracy of a wild soil never before tilled, shaggy with the high red grass that covered plains as yet unbroken by any plow. Such had been the immemorial homeland of the hunting-and-gathering Cheyenne, Arapaho, Comanche, Kiowa, and other Indigenous nations. Such was the original West the first homesteaders came to. Its stubbornness was a trick nature played on the first settlers

(some of whom gave up and went back to where they'd come from, or died by suicide, like Mr. Shimerda, Ántonia's father, in *My Ántonia*). Here is how Alexandra Bergson puts it in *O Pioneers!*: "The land did it. It had its little joke. It pretended to be poor because nobody knew how to work it right: and then, all at once, it worked itself. It woke up out of its sleep." The sea of grass that had covered for numberless ages the landmass from the Missouri to the Rockies became in the course of several decades a breadbasket to the world.

Cather was not slow to note the compensations of the fierce new land: flower-laden springtimes and, above all, brilliant crisp autumns. "In the newest part of the New World," she wrote in her essay on Nebraska, "autumn is the season of beauty and sentiment, as spring is in the Old World." By 1882, the Burlington and Missouri River Railroad was running between Chicago and Denver. Red Cloud was a division point along the line, with its newspapers, banks, stores and hotels, smithy and mill. In Webster County, by the time of Willa's arrival in 1882, there were more immigrants than native stock. She heard a variety of languages and seems to have embraced the confusion almost immediately. After all, she was an immigrant too, and suddenly a member of a minority: the Anglo-Saxon homesteaders.

In the course of the first year on the Divide—as the high ground between the Republican and the Little Blue Rivers

and between the Little Blue and the Platte are known—she thought she'd die of homesickness for northern Virginia with its rolling hills and temperate weather. She and the new land— "as naked as the back of your hand"—had it out before she came to love it. Then the desert place became home.

The babel of Scandinavians and Central Europeans and Frenchmen and more captivated her. In this unlikely place she became a citizen of the world. She would say in a 1913 interview: "We had very few American neighbors. They were mostly Swedes and Danes, Norwegians and Bohemians. I liked them from the first and they made up for what I missed in the country. I particularly liked the old women; they understood my homesickness and were kind to me . . . These old women on the farms were the first people who ever gave me the real feeling of an older world across the sea. Even when they spoke very little English, the old women somehow managed to tell me a great many stories about the old country. They talked more freely to a child than to grown people . . . I have never found any intellectual excitement any more intense than I used to feel when I spent a morning with one of these old women at her baking or butter-making. I used to ride home in the most unreasonable state of excitement; I always felt . . . as if I had got inside another person's skin."

Farm life in rural Webster County did not suit Charles Cather, and after eighteen months he moved his family from

the Divide to Red Cloud proper. Having raised sheep in Virginia, he seemed to have found raising hogs and cattle and breaking the soil in Nebraska more than he could handle. In Red Cloud he established a farm loan, insurance, and real-estate concern and made a go of it. That was the autumn of 1884, the year Willa turned eleven. The town would be transubstantiated into Hanover in *O Pioneers!*, Moonstone in *The Song of the Lark*, Black Hawk in *My Ántonia*, Frankfort in *One of Ours*, Sweet Water in *A Lost Lady*, and Haverford in *Lucy Gayheart*. Thus Cather kept faith with the genius loci of her youth.

Her parents purchased a story-and-a-half frame house on the southwest corner of Third and Cedar, and crowded their growing family of children—Willa, Roscoe, Douglass, Elsie—and Mrs. Cather's mother, and a servant girl, into it. Three more children, John, Jessica, and James, were shortly to follow.

The children slept dormitory-style in the narrow upstairs until Willa, as eldest, got a room of her own—one corner of the L-shaped attic. This became her sanctuary, her solitary reprieve from gregarious family existence. "One realizes," she writes, "that even in harmonious families there is this double life: the group life, which is the one we can observe in our neighbor's household, and, underneath, another—secret and passionate and intense—which is the real life that stamps

the faces and gives character to the voices of our friends. Always in his mind each member of these social units is escaping, running away, trying to break the net, which circumstances and his own affections have woven around him. One realizes human relations are the tragic necessity of human life; that they can never be wholly satisfactory, that every ego is half the time greedily seeking them, and half the time running away from them." These extraordinary insights are from Cather's admiring essay on Katherine Mansfield—with whom she shared a desire to capture definitively the way of life of the childhood place (in Mansfield's case New Zealand) that neither could wait to escape.

The elder personalities of Red Cloud proved nearly as influential on her as family. There was, for example, the Englishman William Ducker, outwardly a failure, who clerked in his prosperous brother's dry goods store and in the evenings read Virgil, Ovid, Homer, and Anacreon with Willa. She would arrive at the University of Nebraska with a solid grounding in classical languages. Ducker was an amateur scientist as well, with a laboratory fitted up at home. Willa assisted him at his experiments. He was her first encounter with a freethinker and set the pattern for her own intellectual outlook. Edith Lewis reports that one afternoon "she was accompanying him home, and he said to her 'It's just as if the lights were going out, Willie.' After she left him a child came

running to call her back. She found Mr. Ducker dead, a copy of the Iliad lying open on the floor beside him."

There was Dr. Robert Damerell, a local physician who took Willa along on his rounds. Present at the amputation of a young boy's leg, she was proudly unfazed. It was in these years that she announced her ambition to be a doctor.

And there was Norwegian-born Julia Miner, mother of the Miner sisters. The Miners would be among Willa's lifelong friends. Mrs. Miner was musically gifted and gave Willa her thrilling first exposure to music. Mrs. Miner would be the prototype for Mrs. Harling in *My Ántonia*: "Her rapid footsteps shook her own floor and she routed lassitude and indifference wherever she came. She could not be negative or perfunctory about anything. Her enthusiasm, and her violent likes and dislikes, asserted themselves in all the everyday occupations of life. Wash-day was interesting, never dreary, at the Harlings'. Preserving-time was a prolonged festival, and house-cleaning was like a revolution."

Willa graduated from Red Cloud High School in June 1890. She came first in a class of three and accordingly delivered the valedictory address. Her spirited theme was "Investigation versus Superstition." She hailed the former and damned the latter. "Since investigation," she declared, "first led man forth on that great search for truth which has prompted all his progress, superstition—, the stern Pharaoh of his former

bondage—, has followed him, retarding every step of the advancement." For its framing of large concepts, its intellectual assurance, its sheer élan, the address would be extraordinary as a college valedictory. In one as young as Willa, here only sixteen, it is unnerving: "There is another book of God than that of scriptural revelation," she declared to her audience, "a book written in chapters of creation upon the pages of the universe bound by mystery."

Two

Outspokenness

———❖———

C harles Cather had to borrow money to pay the modest cost of sending his firstborn to college at Lincoln. Willa proceeded to ransack the place for all she could learn there, where she was initially enrolled in the second-year of the preparatory Latin School, a two-year feeder in conjunction with the university's baccalaureate and graduate programs.

As Jim Burden says in *My Ántonia*: "There was an atmosphere of endeavor, of expectancy and bright hopefulness about the young college that had lifted its head from the prairie only a few years before." Early in 1891 an essay Willa wrote for her English teacher, Ebenezer Hunt, "Concerning Thos. Carlyle,"

appeared in the *Nebraska State Journal* (signed "W. C."). Without her knowledge Professor Hunt had quietly submitted it. Carlyle's *Sartor Resartus* was among the first books Willa bought with her scant funds. She was spellbound by his example—and bedazzled by the sight of her name in print. The dream of being a physician perished in a day. She would be a writer instead. "Up to that time," Cather reported thirty-six years later, "I had planned to specialize in science; I thought I would like to study medicine. But what youthful vanity can be unaffected by the sight of itself in print! It had a kind of hypnotic effect." The discourse on Carlyle was an example of what she would ultimately regard as the worst kind of writing: "very florid and full of high-flown figures of speech." It was also a species of unavowed autobiography: "He was proud to the extreme, but his love was predominant even over his pride." Writing this about Carlyle, she speaks also of herself, of the identity she was casting about for.

She outfitted her off-campus room with a map of ancient Rome, the place she most wanted to see, and a daguerreotype of the Tragic Theater at Pompeii. Spurred by her freedom from home, she began trying on various identities. At this time she was acting and dressing more like a boy than a girl, cropping her hair short, going to class in starched white shirts and suspenders, and affecting a low voice.

She followed up the Carlyle essay with a still more ambi-

tious one, "Shakespeare and Hamlet," in which she declared April 23, Shakespeare's birthday, to have been the date on which "God a second time turned his face in love toward man." This too appeared in the *Nebraska State Journal*.

She was associate editor of the *Lasso*, a new on-campus magazine, which paved the way for more serious editorial work at *The Hesperian*, another campus literary magazine. She had by now graduated from the Latin School and embarked on her freshman year, managing to be simultaneously active in her studies and in local journalism. Her courses included Greek and Latin, Elizabethan poetry, German, and French, along with ample reading of the chief nineteenth-century writers: Austen, George Eliot, Browning, Tennyson, Hawthorne, Emerson, Ruskin, Balzac, Flaubert, Maupassant, Daudet, and others. As well, she took instruction in chemistry, history, rhetoric, journalism, and mathematics (the latter her only weak spot). Her fluent reading of French was a real accomplishment, even though she never learned to speak the language with ease.

The University of Nebraska was new, yes, but with nothing parochial about its offerings. A number of first-class professors had been drawn to Lincoln. Willa was claiming the exceptional education she'd come for. Again, one of her teachers silently submitted work to a magazine, this time *The Mahogany Tree*, a Boston periodical. This was Professor Herbert

Bates, who would serve as the prototype of the dashing Gaston Cleric in *My Ántonia*. Her story was "Peter," published in May 1892, about a fiddle-playing immigrant farmer who despairs and blows his brains out—like Ántonia's father twenty-six years later. The things she'd seen and heard about in youth were already percolating: "[Peter] took Anton's shotgun down from its peg, and loaded it by the moonlight which streamed in through the door. He sat down on the dirt floor, and leaned back against the dirt wall. He heard the wolves howling in the distance, and the night wind screaming as it swept over the snow. Near him he heard the regular breathing of the horses in the dark. He put his crucifix above his heart, and folding his hands said brokenly all the Latin he had ever known, '*Pater noster, qui in coelum est*' . . . He held his fiddle under his chin a moment, where it had lain so often, then put it across his knee and broke it through the middle. He pulled off his old boot, held the gun between his knees with the muzzle against his forehead, and pressed the trigger with his toe." In this first tale she is already transubstantiating memory into art. Those stories of suicides on the plains would always haunt her.

The intelligentsia of Lincoln knew they were in the presence of a phenomenon. Her outspokenness was of a kind rarely known in the diffident Midwest, exciting admiration in some, dislike in others. Among the former were the Westermanns, owners of the *Lincoln Evening News*, who would be

models for the charismatic Erlichs in *One of Ours*; Will Owen Jones, editor of the *Nebraska State Journal*; James Canfield, chancellor of the university, and his painter wife, Flavia. From childhood Willa was drawn to mature people distinguished by independent judgment, intellectual breadth, and personal originality.

And then there was Louise Pound, daughter of an eminent judge—on the evidence a fair match for Cather's leaping intelligence. To Louise she wrote in June 1892: "It is manifestly unfair that 'feminine friendships' should be unnatural." The letter is a profession of love. No other letter like it survives. Is it consciously lesbian? The answer, though not easy, is probably no. Rather than speaking of one kind of love, the letter prefers to talk about love at its most exalted, above the reach of mere carnality. Willa saw herself as exceptional rather than homosexual. But that she was homosexual is obvious, astounded though she would have been to know it. In a letter two years later to Mariel Gere, she writes:

"It is a good thing to love, but it don't pay to love that hard. It makes a fool and dupe of you while you are at it, and then it must end sometime and after it is taken from you the hunger for it is terrible, terrible!"

The pattern of her affective life is here being set. Sexual nature is what she intends to rise above.

Other stories followed "Peter" in *The Hesperian*. There

was "Lou, the Prophet," the tale of a Danish immigrant to the frontier who is driven mad by the obduracy of the soil. Four additional stories ran in *The Hesperian* in 1892 and 1893. These include one of her early best, "The Clemency of the Court," the tragic tale of Serge Povolitchky, a Russian farmhand who avenges himself on the employer who has murdered Matushka, his beloved dog.

On these stories the mature Cather would pass a harsh verdict, attempting to keep them from being reprinted. Here is her response to Edward Wagenknecht when he proposed doing so: "Suppose I were an apple grower, and, packing my year's crop, I were very careful to put only the apples I thought reasonably sound into the packing boxes, leaving the defective ones in a pile on the ground. While I am asleep or at dinner, a neighbour comes to the orchard and puts all the worthless apples into the boxes that are to go to market. Would you call that a friendly action, or the neighbour a friendly man?"

Three

Years of Frenzy

———◆◆◆———

On November 5, 1893, Willa made the leap into journalism with her Sunday column in the *Nebraska State Journal*, called "As You Like It" (and subsequently "The Passing Show"). She was a junior at the university and had not been out of Nebraska since arriving from Virginia at the age of nine. She would file hundreds of pieces for the *Journal* and the *Lincoln Courier* over the next few years. She was launched; she wrote about everything, from Eleonora Duse to cooking tips; editors had only to give her a deadline and a word limit and she was off. Somehow she managed also to carry the

usual course load, edit *The Hesperian*, and serve as literary editor of the university yearbook, the *Sombrero*.

What appealed to her most in her *Journal* column was striking the metropolitan note, escaping the parish, belonging to the great world. When she finally did briefly escape Nebraska, it was in March 1895 for a week of opera-going in Chicago, where the road company of the Metropolitan was performing. Cather was particularly captivated by operas based on Shakespeare and was carried away by the celebrated baritone Victor Maurel as Falstaff: "Of Maurel's singing there is little need to speak; he sings as the greatest baritone in the world should sing. But of Maurel, the actor, it is never too late to speak, the critics of the stage have not told all of it yet, though they have written and talked of little else for thirty years . . . There was a grand and convincing sincerity and reality about the levity and pompousness and amorousness and gigantic vanity of Maurel's knight that made him altogether different and original."

And here she is on one of her passionate loves, Robert Louis Stevenson: "In a generation when fiction is full of the futileness of effort and of flippant scorn for work, he wrote of the glory and the hope of effort and of the completeness which a man's work gives to his life." It is as if she were describing her own as-yet unwritten books. She is in these columns

self-possessed to a fault, your in-the-know girl reporter, over-stuffed with opinions. She can sometimes strike a false note, as when she moralistically condemns Oscar Wilde for his so-called crimes: "The author of 'Helas' is in prison now, most deservedly so. Upon his head is heaped the deepest infamy and the darkest shame of his generation. Civilization shudders at his name, and there is absolutely no spot on earth where this man can live. Cain's curse was light compared with his."

Does it not cross her mind that she and Oscar have a little something in common?

She condemns wholesale the music of Mendelssohn. Not for nothing did Will Owen Jones call her his "meat-ax girl." Her judgments were extreme. Among actresses, Helena Modjeska was a divinity, Lillie Langtry couldn't act at all. As for Lillian Russell, she "not only lacks the power to portray emotion of any kind; she has no sense of humor, she is utterly without enthusiasm, indifferent alike to her part and her audience, even to her own charms. She is a plastic figure . . . All these stories about her improvement in acting and singing are fairy tales." Willa's energetic pose is of the all-knowing connoisseur, her self-assurance and voluminous opinions a court of final appeal. In these brash columns she strives for a knowingness that has got in the way of knowledge, asserting a worldliness of which she's uncertain. She is young and not immune to

posing. That column on Wilde may be the worst thing she was ever guilty of. But near to it is the following boorish passage for a column in the *Courier*: "I have not much faith in women in fiction. They have a sort of sex consciousness that is abominable. They are so limited to one string and they lie so about that. There are so few, the ones who did anything worth while; there were the great Georges, George Eliot and George Sand, and they were anything but women, and there was Miss Brontë who kept her sentimentality under control, and there was Jane Austen who certainly had more common sense than any of them and was in some respects the greatest of them all. Women are so horribly subjective and they have such scorn for the healthy commonplace. When a woman writes a story of adventure, a stout sea tale, a manly battle yarn or anything without wine, women and love, then I will begin to hope for something great from them, not before."

The author of these sentiments may well have been daunting to the young men she met. Willa was sufficiently in demand in those Lincoln years that she required a certain skill at avoiding the path to matrimony. There was one eligible young man in particular, Charles Moore. He gave her a serpent ring that she would wear all her life—perhaps to remind herself of the conventional road not taken? (She and Moore kept up a correspondence for years, both sides of which have unfortunately vanished.)

It was at this time that she met her first great writer, Stephen Crane, whose *Red Badge of Courage* had been serialized in the *Nebraska State Journal*. Only two years older than herself, he had the *poète maudit*'s mark on him when they encountered each other at the offices of the *Journal*. In a perhaps too creative reminiscence published years later, she would recall the "profound melancholy, always lurking deep" in his eyes, which "seemed to be burning themselves out." "I have never known so bitter a heart in any man as he revealed to me that night. It was an arraignment of the wages of life." Crane carried with him that evening, according to Willa, the collected works of Edgar Allan Poe. Is her account of this meeting confected? No doubt it took place. But the particulars sound staged.

In June 1895, two months after the all-important trip to Chicago, Cather graduated from the University of Nebraska. She continued to write for the *Journal* and also, for some months, the *Lincoln Courier*. By early 1896, she had returned to Red Cloud—which she datelines "Siberia" in a letter back to Lincoln. One thinks of that moment in *My Ántonia* when Jim Burden realizes that Black Hawk is simply too Podunk for him: "One could hang about the drugstore, and listen to the old men who sat there every evening, talking politics and telling raw stories. One could go to the cigar factory and chat with the old German who raised canaries for sale. But

whatever you began with him, the talk went back to taxidermy. There was the depot, of course; I often went down to see the night train come in, and afterward sat awhile with the disconsolate telegrapher . . . This guarded mode of existence was like living under a tyranny. People's speech, their voices, their very glances, became furtive and repressed. Every individual taste, every natural appetite, was bridled by caution . . . On Tuesday nights the Owl club danced; then there was a little stir in the streets, and here and there one could see a lighted window until midnight. But the next night all was dark again."

Her attempt in March 1896 to secure a teaching position in Lincoln came to naught. She marked more time back in Red Cloud. Then, three months later, lightning struck. She received an offer from James Axtell at Pittsburgh's *Home Monthly*—a resolutely middlebrow magazine with nothing to offend against prevailing Presbyterian tastes—to join their staff as an associate editor and contributor. E. K. Brown describes the magazine thus: "There were departments devoted to floriculture, fashions, the nursery, Christian endeavor; articles on cycling for pleasure, Angora cats, Harriet Beecher Stowe, and the care of children's teeth."

Still, this was one of those pivotal moments in a life, determining much of what was to come. Here at last, where the Allegheny and the Monongahela meet to form the Ohio, was

a city: pulsing, gritty, prosperous, ambitious. The names to conjure with were Westinghouse, Frick, Mellon, and, above all, Carnegie. Stupendous wealth justified itself in the brick and mortar of libraries and concert halls. The musical and literary life was on a different scale from anything she'd dreamt of. As Red Cloud was too small after Lincoln, so Lincoln was suddenly too small in light of Pittsburgh.

Not that the *Home Monthly* satisfied her ambitions. It was, as she put it, "namby-pamby" in its conventional niceness. She soon tired of furnishing pseudonymous copy about how to cope with a colicky baby or bake a mince pie. Before long she was also writing theater and book reviews for the other Pittsburgh papers. Willa was a "fireman," as newsrooms used to call their most versatile reporters. She continued, additionally, to post reviews back home to the *Nebraska State Journal*. And kept the meat-ax sharp. Here is her disobliging account of a production of *Lohengrin* brought to Pittsburgh by Walter Damrosch's opera: "Frau Gadski who sings Elsa has a very powerful soprano voice and by some strange mischance was not afflicted with a cold. But dramatically she is totally incompetent and unsatisfactory. To begin with she is enormous in size. Her weight is simply preposterous . . . Why is it that all Elsas must be robust and matronly and wearisome to the eye?"

In the spring of 1897, Willa quit her job at the *Home Monthly*, though she continued to contribute an "Old Books

and New" column under one of her wittier pseudonyms, "Helen Delay." That summer she took up duties at the *Pittsburgh Leader*, where she'd remain for four years, contributing a "Books and Magazines" column. She also continued her "Passing Show" column for the *Lincoln Courier*.

These were "years of frenzy," as she called them, in which well over a million words of journalism flowed from her pen. Few other novelists have had such a vast journalistic foreground. (One thinks of George Eliot writing anonymously for the *Westminster Review* and Virginia Woolf contributing unsigned notices to the *Times Literary Supplement*.) Cather never afterward talked about this journeywork and did not want any of the pieces plucked from oblivion. Still, journalism had been the making of her. She'd built herself a lasting frame of reference.

It was in the course of 1899 that she met her great love, Isabelle McClung, daughter of Samuel McClung, a wealthy and prominent Pittsburgh judge, who had presided ten years earlier at the trial of Alexander Berkman, would-be assassin of Henry Clay Frick and companion of fellow anarchist Emma Goldman. The meeting took place in the dressing room of actress Lizzie Collier and the attraction was immediate. Cultivated, well traveled, literate, winningly feminine, Isabelle was at once Willa's other half. The McClungs' spacious, sternly Scotch home at 1180 Murray Hill Avenue, at the crest

of the street, its front porch banked with honeysuckle, in the Squirrel Hill neighborhood of Pittsburgh, was a second home to Willa, and within two years she'd moved in, writing in a converted sewing room at the top of the house recalling her attic room in Red Cloud and presaging Godfrey St. Peter's sewing room study in *The Professor's House*. There she worked for the remainder of her Pittsburgh years, evidently much loved by Judge McClung and his wife, Fannie; and often returned, after moving to New York, to write in the third-floor sewing room. Isabelle was a willing muse. Willa would declare, following Isabelle's death in 1938, that all her novels and stories had been written for Isabelle.

Meanwhile, her attempts at fiction had begun to bear fruit. While still living at a boardinghouse on Sheridan Avenue, she'd published "Eric Hermannson's Soul" in *Cosmopolitan*, her first appearance in a high-profile magazine. While no one would mistake this slight tale for major work, it marked a stage on the way.

After her move to the McClungs', Willa took up teaching duties in the spring of 1901 at Central High School. For the remainder of her Pittsburgh years—that is, until 1906—she continued to instruct in Latin, English, and algebra there and, later, at Allegheny High School.

The summer of 1902 would prove her most exciting and rewarding to date. At twenty-eight, accompanied by Isabelle,

she embarked on the *Noordland* for Liverpool on a three-month European tour. July first, their date of disembarkation, had been planned in Great Britain as Edward VII's coronation day, but owing to a case of kingly appendicitis, the ceremony had to be postponed. Willa noted that the banners saying GOD SAVE OUR KING were being replaced by banners saying GOD RAISE OUR KING, as she reported back to the *Nebraska State Journal*.

In certain respects, Great Britain compared unfavorably to home. "I have been in England a week now," she writes, "and I have not seen an English girl or woman of the middle class who is not stoop-shouldered to a painful degree, or who does not stand with her chest sunk in and the lower part of the torso thrust forward. Even in the little, little girls one sees the beginning of it. The topping of the shoulders and contraction of the chest. This unfortunate carriage is so universal that it amounts to a national disfigurement among the women."

Inspired by a shared love of A. E. Housman's poetry, Willa and Isabelle included Shropshire on their itinerary. "The remoteness, the unchangedness and time-defying stillness of much of the Shropshire country perhaps explains Mr. Housman as well as its own singularly individual beauty." An actual meeting with the poet did not go as hoped. He was taciturn and formal. It surely did not crowd his mind that he was meeting a great writer in the making.

In London, she witnessed certain perennial scenes: "Time and again we have seen sturdy, bonny, well-dressed little children trying with the most touching seriousness and gentleness to steer home two parents, both of whom were so far gone in their cups that the little folk had great ado to keep them on their feet at all." As well, from London, she reported on things that had not happened. An alleged visit to the Kensington studio of Edward Burne-Jones, presented as fact to a trusting *Journal* readership, has been demonstrated to be entirely fictitious.

England was all very well, but it was France that had been the goal of Willa's young life. "Certainly so small a body of water as the English Channel never separated two worlds so different. In the railway station here every poster was a thing of grace and beauty." This idealization was something carried from youth into adulthood. France had been a second homeland long before she ever set foot on French soil. She saw France as the civilization against which others were to be measured, a familiar American weakness. Through incessant reading and bookish mastery of the language—studied from childhood on—she'd made herself at home in all things French. She and Isabelle spent six ravenous weeks touring Normandy, Paris, and the Midi. Here she is inspecting the cathedral at Rouen, a Gothic masterwork behind whose choir is buried the heart of Richard Coeur de Lion: "The interior is

vested with a peace that passes understanding. The columns and arches are beautifully fluted and of the most delicate and slender gothic, vault after vault rising high and as effortless as flame. The uniform whiteness of the walls and arches and high slender columns is varied by the burning blue and crimson of two rose windows almost as beautiful as those of Notre Dame . . . All the light streams from the windows so high that one seems to look up at them from the bottom of a well." And here is her assessment of Rouen more generally: "a well-fed self-satisfied bourgeois town built upon the hills beside the Seine, the town where Gustave Flaubert was born and worked and which he so sharply satirized and cursed in his letters to his friends in Paris. In France it seems that a town will forgive the man who curses it if only he is great enough."

Paris was the ultimate revelation. "There is a rue Balzac," she wrote home to Nebraska, "and rue Racine and rue Molière as well as a Place Wagram and a rue Arcola. Nearly every street in Paris bears the name of a victory—either of arms or intellect." At Père-Lachaise and other cemeteries she made obeisance at the graves of the greats, taking flowers to Heine and others.

Provence provided other sorts of pleasure. At Avignon she praised the Rhône as "not one of your clear English streams that wind through rose-hedged meadows, but a great, green flood of water, sweeping swift and fiercely along between its

banks of red clay." The more glamorous watering places, by contrast, left her cold: "I had a continual restless feeling that there was nothing at all real about Monte Carlo; that the sea was too blue to be wet, the casino too white to be anything but pasteboard, and that from their very green the palms must be cotton."

Four

The Big Clean Up-Grade

Cather published her first book, *April Twilights*, a collection of thirty-seven poems, with a vanity press run by one Richard Badger. That it found any reviewers at all seems remarkable. The poems are pale evocations of Dante Gabriel Rossetti and other fashionable writers of her youth and make clear that poetry was not to be Willa's calling. At about the same time, she sent out a sheaf of stories to S. S. McClure, editor of the most exciting publication of the day, *McClure's Magazine*. And struck pay dirt; he invited her to visit him at his offices in New York. At this meeting, on May 1, 1903, he promised to publish her work in his magazine as well as in

book form. She returned to Pittsburgh and the McClungs and Allegheny High a different person.

The book that resulted, *The Troll Garden*, appeared early in 1905. Among her short fiction of lasting significance are three especially strong early efforts: "A Wagner Matinee," "The Sculptor's Funeral," and a story arising from her teaching experience, "Paul's Case." In "A Wagner Matinee," a ground-down farm woman, Georgiana, recollects the world of music, and promise of a musical career, left behind when she moved from Boston to Nebraska. Now she has sun-baked skin and ill-fitting false teeth and is prematurely old. Having returned to Boston for a visit after more than thirty years, she experiences again the lost love of music when her citified nephew, the story's narrator, takes her to a matinee of the Boston Symphony. The effect is shattering: "I heard a quick-drawn breath and turned to my aunt. Her eyes were closed, but the tears were glistening on her cheeks, and I think, in a moment more, they were in my eyes as well. It never really died then—the soul which can suffer so excruciatingly and so interminably; it withers to the outward eye only; like that strange moss which can lie on a dusty shelf half a century and yet, if placed in water, grows green again. She wept so throughout the development and elaboration of the melody."

The story had first appeared in *Everybody's Magazine* in

March 1904 and, from the disapproving response of Nebras-
kans, convinced Cather she'd done something right. In Jan-
uary 1905, "The Sculptor's Funeral" had appeared in *McClure's*.
It takes place in "a dead little Western town," Sand City, Kan-
sas, to which the body of the esteemed sculptor Harvey Mer-
rick is being borne. Esteemed by the world, yes, but not by the
philistine hometown, where he is considered an embarrass-
ment. Sand City is a little world of small-minded gossip and
proud ignorance. The wonder is that it has produced a master
artist. At the climax the town lawyer, ashamed of himself and
of his fellow mediocrities, denounces the leading citizens one
after the other. Harvey Merrick, he says, was worth the lot of
them. "I came back here and became the damned shyster you
wanted me to be. You pretend to have some sort of respect for
me, and yet you'll stand up and throw mud at Harvey Mer-
rick, whose soul you couldn't dirty and whose hands you
couldn't tie. Oh, you're a discriminating lot of Christians!
There have been times when the sight of Harvey's name in
some Eastern papers made me hang my head like a whipped
dog; and again, times when I liked to think of him off there
in the world, away from all this hog-wallow, climbing the big
clean up-grade he'd set for himself."

"Paul's Case," Cather's first undoubted masterpiece, tells
the tale of a floundering high school boy in love with beauty

and make-believe: "His eyes were remarkable for a certain hysterical brilliancy, and he continually used them in a conscious, theatrical sort of way, peculiarly offensive in a boy." In a letter to a reader, a Mr. Phillipson, Cather wrote: "I once had in my Latin class a nervous, jerky boy who was always trying to make himself 'interesting.'" Paul steals money in order to go to New York, check into the Waldorf, and live out a fantasy of ease and elegance. "On Sunday morning the city was practically snowbound. Paul breakfasted late, and in the afternoon he fell in with a wild San Francisco boy, a freshman at Yale, who said he had run down for a 'little flyer' over Sunday. The young man offered to show Paul the night side of the town, and the two boys went off together after dinner, not returning to the hotel until seven o'clock the next morning. They had started out in the confiding warmth of a champagne friendship, but their parting in the elevator was singularly cool." What has transpired between them? Something sexual? The story is reticent, but a homosexual encounter would be in keeping with the rest of the tale. Meanwhile, back in unforgiving, unlovely Pittsburgh, the news of Paul's theft has hit the papers. Reality is closing in. "He would show himself that he was game, he would finish the thing splendidly." With time run out on his desperate escapade, he thinks of unseen places, the blue of the Adriatic, the yellow of North African sands. And throws himself in front of an oncoming train. "He

felt something strike his chest,—his body was being thrown swiftly through the air, on and on, immeasurably far and fast, while his limbs gently relaxed. Then, because the picture-making mechanism was crushed, the disturbing visions flashed into black, and Paul dropped back into the immense design of things."

No summary can do justice to the delicate emotional accuracy of this tale, which both reviles and sides with the poor boy's fantasy life.

The Troll Garden's epigraph comes from Charles Kingsley—

A Fairy Palace, with a fairy garden, . . .
Inside the trolls dwell, . . . working at
Their magic forges, making and making always
Things rare and strange.

All the book's stories, one way or another, concern themselves with the promise and peril of art and the artistic temperament. Critics were hard on *The Troll Garden*. The only signed review, by Bessie du Bois in *The Bookman*, called it "a collection of freak stories that are either lurid, hysterical, or unwholesome and that remind one of nothing so much as the colored supplement to the Sunday papers." Undaunted, Cather continued her teaching duties at Allegheny High. At the end of the 1905 school year she went west to the South

Dakota Black Hills, Nebraska, and Wyoming. She was avidly garnering impressions.

That December in New York, at Delmonico's Hotel, Willa was among the 170 celebrants of Mark Twain's seventieth birthday. It seems that McClure had arranged the invitation. She had remained on his mind: Before the end of the school year he prevailed on her to come to New York and take up duties as a *McClure's* editor. Worth quoting in its entirety is the letter she penned to her Allegheny homeroom class, dated June 6, 1906:

> *Dear Boys and Girls:*
>
> *Now that I find I shall not return to the High School next fall, I have a word to say to you. A number of my pupils in various classes, and especially in my Reporting Class, asked me, when I came away, whether I should be with you next year. At that time I fully expected to be. The changes in my plans which will prevent my doing so have been sudden and unforeseen. I should hate to have you think that I had not answered you squarely when you were good enough to ask whether I should return, or to have you think that I put you off with an excuse.*
>
> *I had made many plans for your Senior work next year and had hoped that we should enjoy that work together. I*

must now leave you to enjoy it alone. One always has to choose between good things it seems. So I turn to a work I love with very real regret that I must leave behind, for the time at least, a work I had come to love almost as well. But I much more regret having to take leave of so many students who I feel are good friends of mine. As long as I stay in New York, I shall always be glad to see any of my students when they come to the city.

I wish you every success in your coming examinations and in your senior work next year.

Faithfully yours
Willa Cather

The letter, so diplomatic about where her professional priorities lie, is also full of pedagogical pride. She knows she'll not be easily replaced.

In 1906, *McClure's*, under the inspired if frantic leadership of S. S. McClure, was a very famous magazine, famed for muckraking exposés by Ida Tarbell, Lincoln Steffens, and Ray Stannard Baker, as well as fiction by Thomas Hardy, Arnold Bennett, Joseph Conrad, Rudyard Kipling, and a host of others nearly as distinguished. The first magazine account of the Wright brothers' flight at Kitty Hawk ran in *McClure's*, as did a scoop on Marconi's first demonstration of wireless

telegraphy. Ida Tarbell's exposé of Standard Oil became a national sensation, as did Steffens's report on city hall corruption in Minneapolis.

But Sam McClure, who suffered from what today would be called bipolar illness, was a hard man to work for. By 1906, Tarbell and Steffens had resigned. Such was the chaotic situation Cather stepped into. She seems to have known how to handle Sam better than most people. Eight months into her employment he gave her an important assignment. The magazine had in its files a sketch for a book—not in publishable form—by Georgine Milmine on Christian Science and its founder, Mary Baker Eddy. Cather moved to Boston, took an apartment on Chestnut Street, and set to work filling out the profile. The twin tasks of fact-checking and rewriting Milmine's disorderly prose would consume all of 1907 and about half of the following year, after which "Mary Baker G. Eddy: The Story of Her Life and the History of Christian Science" ran in fourteen installments of the magazine, and was subsequently brought out in book form by Doubleday. The reality of Cather's authorship of Milmine's series and book remained a well-guarded secret.

She was befriended in Boston by Mrs. Louis D. Brandeis; it was through her that she afterward met Annie Fields, widow of James T. Fields, original publisher of Ticknor and Fields. This was shaking hands with history; Mrs. Fields's husband

had published Hawthorne and Emerson. Twenty-seven years a widow, she lived on at 148 Charles Street, a house whose threshold had been crossed in the olden days by not just Emerson and Hawthorne but Dickens, Thackeray, and Matthew Arnold. Cather would later describe the Charles Street residence as "an atmosphere in which one seemed absolutely safe from everything ugly . . . It was indeed the peace of the past, where the tawdry and cheap have been eliminated and the enduring things have taken their proper, happy places."

At this sanctified address Cather made one of the most significant, if briefest, friendships of her life. Sarah Orne Jewett, to whom she'd dedicate *O Pioneers!*, was well-known as the author of *The Country of the Pointed Firs*. To actually meet her, now far gone in age, seemed as improbable as meeting Hawthorne himself. Cather had been familiar with her book since its appearance in 1896. Here was a living author, and mother-figure, she could unconditionally look up to. From Jewett supremely she'd learn to love the parish by way of the world and the world by way of the parish; to love the place of origin by instinct, but in the light of wide experience; thus, simultaneously, from near and from afar.

In April 1908, Cather found she could get away to Europe, again with Isabelle—this time to Italy, which was as deep a revelation as France had been on their first journey abroad. Florence, Rome, Naples, Capri, and Amalfi were among the

destinations. Here is her first encounter with Naples, in a letter to Alice E. D. Goudy: "I sit there every afternoon and watch Vesuvius change from violet to lilac and then to purple. I could almost throw a stone over to the tiny island of Megares where Lucullus had his gardens and where Brutus met Cicero after the murder of Caesar." And here is Willa writing to Miss Jewett from Ravello, that matchless hill town above the Amalfi Coast: "Seven hundred years ago yesterday a galley from the Holy Land first brought St. Andrew's skull to Amalfi, in Amalfi's time of sea-sovereignty. Every hundred years the arrival of the skull is celebrated. It was brought back to Amalfi yesterday by a fleet of forty-seven vessels, and the cardinal from Rome was down at the marina to receive it. The bells in Ravello rang all day long and the whole countryside trooped down to Amalfi."

Back home, Cather was at this time living at 60 Washington Square South, where she barely had time to reacclimate in August before becoming, suddenly, managing editor of *McClure's*, in fact if not in title. She knew that commissioning copy and getting out the magazine were impeding her growth as an artist. She wrote to Miss Jewett that "reading so much poorly written matter as I have to read has a kind of deadening effect on me somehow. I know that many great and wise people have been able to do that, but I am neither large enough nor wise enough to do it without getting a kind of dread of

everything that is made out of words. I feel diluted and weakened by it all the time—relaxed, as if I had lived in a tepid bath until I shrink from either heat or cold." However exasperating these crowded years became, she knew she had another goal that was the opposite of deadline journalism. Being an editor, as she said, was like going every which way by train but never getting off to see things close-up. And to see things as close-up as anyone before her was the ultimate ambition. "I have not a reportorial mind," she wrote to Miss Jewett. "—I can't get things in fleeting glimpses and I can't get any pleasure out of them."

Still, at least one truly first-class story got written amid the journalistic frenzy and that was "The Enchanted Bluff," a plotless but compelling evocation of boys on a camping trip on the Republican River. The six of them share a charmed night around a campfire just before dispersing to their various fates. The story is narrated twenty years on by one of the boys. Cather has touched deeply on what Jewett advised was her forte: the little world of origins, recollected in tranquility.

In the summer of 1903, Willa had met a young Smith graduate named Edith Lewis. They stayed in touch and in 1908, when Cather assumed her duties as managing editor, she brought Edith to New York as the magazine's proofreader. They lived in the same apartment building at 60 Washington Square South. Friendship between the two women deepened

into love and from Cather's return from Boston they had been living together at 82 Washington Place. They got breakfast and lunch for themselves and, three days a week, dinner. Otherwise they dined at the Brevoort Hotel. Twice a week a housemaid was in. Such were the beginnings of their long domestic accord; Edith would be first mate to Willa's captaincy for four decades. As for appearances, the two women gave them little thought; two spinsters living together in order not to be alone excited little speculation. That the bond was connubial simply did not occur to people.

During her first year as managing editor, the circulation of *McClure's* rose by sixty thousand. And yet the magazine could not turn a profit; the boss's talent for debt equaled his knack for publishing. Sam McClure had sense enough to value Cather, who'd bought fiction by Theodore Dreiser, Arnold Bennett, Jack London, and others, and commissioned several ambitious series in the muckraking tradition. In May 1909, McClure dispatched Cather to England on a scouting trip. There she met H. G. Wells, Edmund Gosse, Ford Madox Ford (then Hueffer), and others.

In London, Cather received word that Sarah Orne Jewett had died. Despite their having been friends so briefly—about sixteen months—this was a grievous loss, the most painful of her life thus far. To Annie Fields, Jewett's companion, she wrote: "When one is far away like this one cannot realize

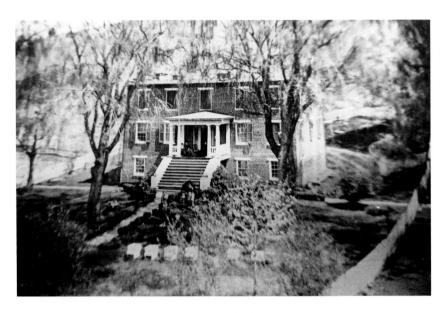

Willow Shade

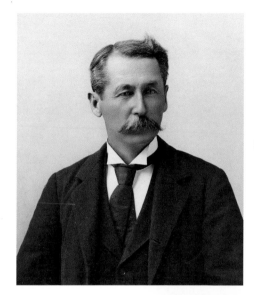

Charles Cather

Mary Virginia Cather

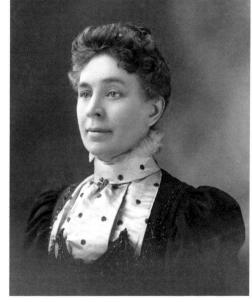

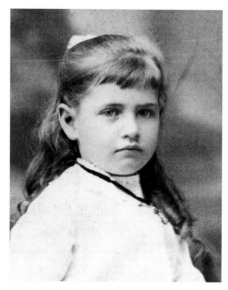

Willa as a child

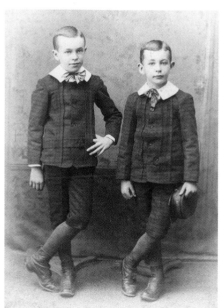

Roscoe and
Douglass Cather

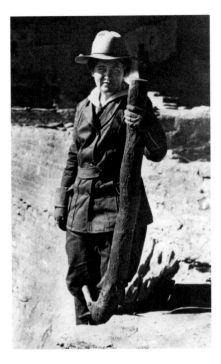

Willa at
Mesa Verde

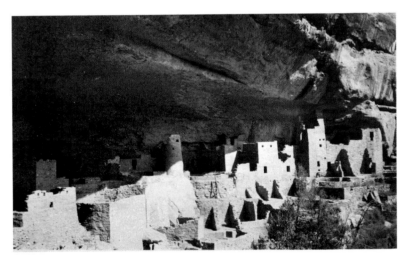

Cliff House, Mesa Verde

Aunt Franc

G. P. Cather

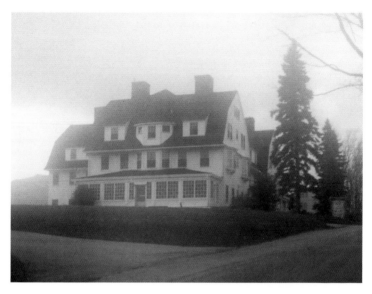

Shattuck Inn

Grand Manan cottage

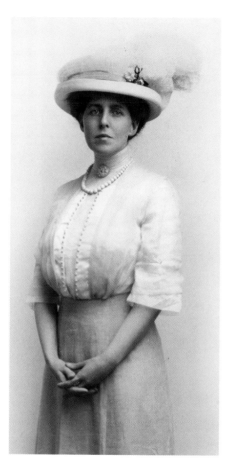

Isabelle McClung
Hambourg

Edith Lewis

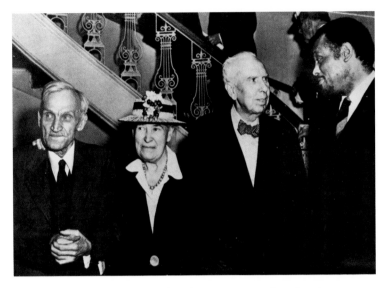

S. S. McClure, Cather, Theodore Dreiser, and Paul Robeson

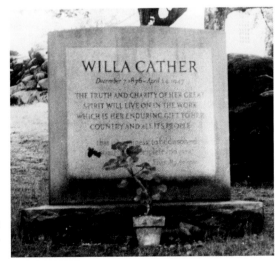

Gravestone
in Jaffrey

death. Other things become shadowy and unreal, but Miss Jewett herself remains so real that I cannot get past the vivid image of her to any other realization. I know that something has happened only by the numbness and inertia that have overcome me. I find that everything I have been doing and undertaking over here I have done with a hope that it might interest her . . . And now all the wheels stand still and the ways of life seem very dark and purposeless."

On her return she plunged back into long days and evenings at the magazine's offices on East Twenty-Third Street, wondering how she would ever escape. She owed it to Jewett's memory to write fiction of which her mentor would approve. As for the magazine, it found itself in receivership by early 1911. Sam had reached the end of his tether. He was forced to sign a contract leasing *McClure's* with an option to purchase. Thus was he unhorsed after twenty years as founder and familiar spirit. For both Sam and Willa it was the end of an era. She took this as her cue to resign.

Some months later she submitted to the magazine, under cover of the pseudonym "Fanny Cadwallader," a novel called *Alexander's Bridge*. When it was accepted she revealed the ruse. *Alexander's Bridge*, called "Alexander's Masquerade" when *McClure's* serialized it, tells the story of Bartley Alexander, a preeminent North American bridge-builder. The book uses settings in Boston and London that Cather had only

recently acquainted herself with. "[I]t is not always easy," she would observe a decade later, "for the inexperienced writer to distinguish between his own material and that which he would like to make his own. Everything is new to the young writer, and everything seems equally personal. That which is outside his deepest experience, which he observes and studies, often seems more vital than that which he knows well, because he regards it with all the excitement of discovery. The things he knows best he takes for granted, since he is not continually thrilled by new discoveries about them. They lie at the bottom of his consciousness, whether he is aware of it or no, and they continue to feed him, but they do not stimulate him."

That the novel of manners was not her métier she had to learn the hard way, by writing one. *Alexander's Bridge* is a case of borrowed finery, as she felt almost immediately on its completion. Still, reading it today one finds much to admire in the book's tragic love triangle. *Alexander's Bridge* tells very dramatically of the moral collapse of a life, as well as the physical collapse of a bridge. Loving his wife in Boston, in love with his mistress in London, Bartley goes as a torn soul to his death when the bridge collapses ("something was out of line in the lower cord of the cantilever arm"). One cannot help suspecting Cather was here expressing the divided state of her own personal life, split as it was between two women, Isabelle and

Edith. This cannot be demonstrated. I only propose it here as a possibility.

Bartley Alexander wants more from life than life has to give. "There were other bridge-builders in the world, certainly," writes Cather, "but it was always Alexander's picture that the Sunday Supplement men wanted, because he looked as a tamer of rivers ought to look. Under his tumbled sandy hair his head seemed as hard and powerful as a catapult." But there is a fault in him, as in his bridge. His old teacher Lucius Wilson seems to know as much and says to him: "I always used to feel that there was a weak spot where some day strain would tell. Even after you began to climb, I stood down in the crowd and watched you with—well, not with confidence. The more dazzling the front you presented, the higher your facade rose, the more I expected to see a big crack zigzagging from top to bottom."

In 1931, looking back, Cather published an essay called "My First Novels (There Were Two)." "London," she wrote, "is supposed to be more engaging than, let us say, Gopher Prairie; even if the writer knows Gopher Prairie very well and London very casually." The return to native ground, prompted by advice from that best of local colorists, Sarah Orne Jewett, would be momentous, giving back to Cather a birthright. About the false start of *Alexander's Bridge*, she wrote: "Soon

after the book was published I went for six months to Arizona and New Mexico. The longer I stayed in a country I really did care about, and among people who were part of the country, the more unnecessary and superficial a book like *Alexander's Bridge* seemed to me."

In *O Pioneers!*, the second first novel, she writes to her strong suit, the Nebraska Divide: "the great fact was the land itself, which seemed to overwhelm the little beginnings of human society that struggled in its sombre wastes." As elemental as the setting is the story—a love triangle ending in two deaths and an imprisonment for life. Cather had begun with the narrative of Alexandra Bergson, a Swedish farm woman breaking the wild land. She then wrote "The White Mulberry Tree," about the fatal triangle. In a moment of creative excitement she saw that these two tales were part of one novel. Thus *O Pioneers!*, her "two-part pastoral," was born. (An examination of the rather unpersuasive pastoral that preceded it, "The Bohemian Girl," her first extended portrait of immigrants on the Divide, reveals how far she has leapt at one go.)

Carl Linstrum, the great friend of her youth, says to Alexandra: "There are only two or three human stories, and they go on repeating themselves as fiercely as if they had never happened before; like the larks in this country, that have been singing the same five notes over for thousands of years." The book is vivid and profound, a new level of achievement, and

drawn from the deepest stratum. "The shapes and scenes that have 'teased' the mind for years, when they do at last get themselves rightly put down, make a very much higher order of writing, and a much more costly, than the most vivid and vigorous transfer of immediate impressions," wrote Cather. Alexandra Bergson, surely one of her most memorable heroines, has had no time or inclination for romance. A man's responsibilities have been thrust on her. Her brother Emil has meanwhile fallen helplessly in love with Marie Shabata, unhappily married to Frank Shabata, who will surprise the lovers together and kill both beneath the mulberry tree.

In the climactic scene, Alexandra visits Frank, murderer of her brother, in prison. The unexpected miracle of the book is that she has forgiven him. In a moment of Chekhovian subtlety, he reaches out, as she is leaving, and touches a button of her jacket. In the epilogue, the full force of Cather's antipathy to sexual love becomes apparent. Attached from youth to Carl Linstrum, though never erotically, Alexandra founds with him a life that would seem to leave all care for sex behind. "Do you feel at peace with the world here?" she asks him. "I think we shall be very happy. I haven't any fears. I think when friends marry, they are safe. We don't suffer like—those young ones." Here, as so often in Cather, sexual need is the flaw in human nature. She was against it; her great protagonists rise above it: Alexandra Bergson, Thea Kron-

borg, Tom Outland; above all, the nobly unsexed priests of *Death Comes for the Archbishop*. Her lesser protagonists are variously doomed by it: Emil and Marie in *O Pioneers!*, Marian Forrester, Lucy Gayheart.

Willa retreated to her old sewing room at the McClungs' to achieve the revisions that would wed "Alexandra" and "The White Mulberry Tree." She sent the finished manuscript to Ferris Greenslet of Houghton Mifflin, who immediately accepted the book—to Cather's surprise, as she imagined the Henry James manner of *Alexander's Bridge* more to his liking. The book would come out in the summer of 1913 to exceptionally strong reviews. An unsigned notice in *The Nation* was typical: "The sureness of feeling and touch, the power without strain . . . lift it far above the ordinary product of contemporary novelists."

At forty, Willa had arrived.

Five

Breaking Free

———✦———

On her return from Pittsburgh to New York she'd set to work moving from 82 Washington Place to a spacious new apartment Edith had found for them at 5 Bank Street—seven high-ceilinged rooms, one flight up, with two coal-burning fireplaces, a good kitchen, plenty of light, and views to the sycamore-lined street. Best of all was a little study off the living room, in which much of the work to come would be done. They'd moved in on New Year's Day of 1912.

Cather was never a lover of New York. To Elizabeth Shepley Sergeant she wrote: "You cannot go a block in any direction without encountering a steam hammer and an iron drill.

All the pavements are being repaired and all the sewer pipes are being changed. The place couldn't be more smelly and noisy so we shall be in a pitiable state when it does get hot." But 5 Bank Street offered an elegant haven. And they had hired a first-rate French housekeeper and cook, Josephine Bourda, as well as someone they referred to as their "colored maid" to do the housework. Willa went each morning to the Jefferson Market, two blocks away, to pick out the produce and viands for lunch and dinner.

She was busy throughout the summer of 1913—the summer of her triumph with *O Pioneers!*—doing a large favor. She had consented to write Sam McClure's autobiography, basing it solely on his spoken recollections. When it began to be serialized in *McClure's*, prior to book publication, it carried the following headnote from the supposed author: "I wish to express my indebtedness to Miss Willa Sibert Cather for her invaluable assistance in the preparation of these memoirs." She'd written every word of them.

A further obligation to *McClure's* was a feature to be called "Three American Singers." Louise Homer, Geraldine Farrar, and Olive Fremstad were the subjects. Neither Homer nor Farrar much engaged her, but Fremstad would inspire Cather's next work of fiction, *The Song of the Lark*, which tells the story of a Swedish girl from Moonstone, Colorado—another iteration of Red Cloud—who grows up to be the leading Wag-

nerian soprano of her time. Cather found in Fremstad her artistic equal. She wished to write all that Fremstad had done and suffered and known, and such was the germ of *The Song of the Lark*, an *Entwicklungsroman* or *Künstlerroman* telling of the apotheosis of a great singing artist.

About the book Cather wrote exuberantly to Ferris Greenslet, her editor at Houghton Mifflin: "I tell you I've *got it*, this time!" The novel is long and leisurely. Within a decade of writing it she regretted the fullness of detail and profusion of secondary characters. Her fiercest judgment on *The Song of the Lark* came in 1922 with her essay "The Novel Démeublé," where she would write: "The novel, for a long while, has been over-furnished. The property-man has been so busy on its pages, the importance of material objects and their vivid presentation have been so stressed, that we take it for granted whoever can observe, and can write the English language, can write a novel. Often the later qualification is considered unnecessary."

But *The Song of the Lark* is strong work. The musical motif is carried through with conviction and finesse. And the withering away of the heroine Thea Kronborg's personal life as she fulfills her artistic destiny provides a strong narrative line. Here is young Thea in a little end room of the half-story attic at home in Moonstone, fitted up for her by the family and a simulacrum of Willa's attic room in Red Cloud: "In the end of the wing, separated from the other upstairs sleeping-rooms

by a long, cold unfinished lumber-room, her mind worked better. She thought things out more clearly. Pleasant plans and ideas occurred to her which had never come before. She had certain thoughts that were like companions, ideas which were like older and wiser friends. She left them there in the morning, when she finished dressing in the cold, and at night, when she came up with her lantern and shut the door after a busy day, she found them awaiting her." In this *sanctum sanctorum*, frigid in winter, blistering in summer, young Thea comes into her own. "From the time when she moved up into the wing, Thea began to live a double life. During the day, when the hours were full of tasks, she was one of the Kronborg children, but at night she was a different person." Her self-confidence, "that sturdy little companion," assured her that "she had an appointment to meet the rest of herself sometime, somewhere. It was moving to meet her and she was moving to meet it."

Midway, the novel pivots to a large ranch in northern Arizona owned by the family of Fred Ottenburg, Thea's suitor. There she has retreated, at his suggestion, to rest and think in solitude. She is especially intrigued by the nearby Anasazi cliff habitations in Panther Canyon (inspired by Walnut Canyon, north of Flagstaff, which Cather had visited in 1912 on her first visit to the Southwest). "All the houses"—the eyelet-shaped cliff dwellings—"in the canyon were clean with the

cleanness of sun-baked, windswept places, and they smelled of the tough little cedars that twisted themselves into the very doorways. One of these rock houses Thea took for her own . . . This was her old idea; a nest in a high cliff, full of sun."

From this exalted solitude a new certainty grows. The heroic example of the Ancient People, gone for most of a millennium, draws near to her: "The stream and the broken pottery: what was any art but an effort to make a sheath, a mould in which to imprison for a moment the shining, elusive element which is life itself—life hurrying past us and running away, too strong to stop, too sweet to lose?"

This is a passionate humanism or lengthening of one's past based in reverence for all who've made the hardest start against the elements: "All these things made one feel one ought to do one's best, and help to fulfill some desire of the dust that slept there . . . These potsherds were like fetters that bound one to a long chain of human endeavor."

Thea grows more and more complete in herself. When Fred asks her what she would think of a nice little family life she says: "Perfectly hideous!" It is the answer he was expecting. "You're not a nest-building bird," he tells her. While they will become lovers, this is perhaps the first novel of note in which love and matrimony are unimportant to the heroine. In the book's final section—called simply "Kronborg," as one would say "Fremstad" or "Schwarzkopf" or "Callas"—we

meet Thea ten years later at the zenith of her career. On stage she has retained the gift of looking radiant, even if she looks aged and shattered after a performance. In a matter-of-fact way she has gone ahead and married Fred Ottenburg, again on the principle that when friends wed they are safe. In what other novel before this one do love, marriage, and reproduction register so weakly? (In the 1930s, in Houghton Mifflin's collected edition of her works, Cather will repent of the explicit marriage of Thea and Fred, blue-penciling it along with what she'd come to regard as various other excesses, about eight thousand words in all.) She says to Fred: "Who marries who is a small matter, after all. But you've cared more and longer than anybody else, and I'd like to have somebody human to make a report to once in a while." *The Song of the Lark* is a work of stunning originality—if not of style then of substance. No character like Thea preexists her in literature. She is without precursor. Eleven years after publishing *The Song of the Lark* Cather would write to Alfred Knopf, her publisher after she left Houghton Mifflin: "What I want to do is to find a few qualities, a few perfumes, that haven't been exactly named and defined yet." By the standard of this sober-minded statement of ambition, she has succeeded splendidly in *The Song of the Lark*.

One hallmark of Cather's work is the depiction of unhappy marriages. A particularly ghastly union is that of Doctor and Mrs. Archie back in Moonstone. The doctor is Thea's selfless

benefactor throughout. His wife is a fanatical housekeeper: "It was his wife's custom, as soon as Doctor Archie left the house in the morning, to shut all the doors and windows to keep the dust out, and to pull down the shades to keep the sun from fading the carpets. She thought, too, that neighbors were less likely to drop by if the house was closed up. She was one of those people who are stingy, without motive or reason, even when they can gain nothing by it." Her passion for housecleaning will prove her undoing. Rubbing the parlor upholstery one day with gasoline, she blows herself up. Cather's delight is palpable.

The book teems with characters suggested by real persons. Doctor Archie, for instance, is drawn from Dr. Damerell, the Red Cloud physician who'd taken young Willa along on his rounds. The impecunious piano teacher, A. Wunsch, is based on Herr Schindelmeisser, Willa's piano teacher. The railroad brakeman who bequeaths Thea six hundred crucial dollars was inspired by a brakeman named Tooker whom she got to know on her 1912 trip to Arizona.

The Song of the Lark is best understood as a simultaneous portrait of herself and Fremstad. After reading the book, she told Cather she couldn't tell where one left off and the other began. So many details about Thea's life derive from the great soprano. For example, Thea's father, like Olive's, is a minister. Like Olive, Thea plays organ and teaches in church. Still, so much of Thea's aspiration and inner life are pure Willa.

The book's title has been a source of confusion. It makes reference to Jules Breton's painting of a Breton girl stopping at daybreak to hear the song of the lark. Cather meant the title to suggest awakening, promise—a too-heavy suggestion, she later felt, agreeing with the book's detractors. In general, a nineteenth-century fullness is what some faulted the book for. A critic Cather much admired, Randolph Bourne, said in an unsigned review in *The New Republic* that the novel should have ended two hundred pages earlier than it does. While she wouldn't have gone that far, "The Novel Démeublé" suggests how uncomfortable she later grew with the book. My own view is that it is a major work, hard to gainsay in its persuasiveness. A lasting novel, according to Cather, is something you've lived through, not just a story you've read. *The Song of the Lark* meets that test. As Cather writes to an admiring reader, Helen Seibel: "You seem to have liked the book in the way I wanted it liked, and to have read it in the spirit in which I wrote it. If I had written a preface to the book, I would have said 'I for one am tired of ideas and "great notions" for stories. I don't want to be "literary." Here are a lot of people I used to know and love; sit down and let me tell you about them.'"

In the summer of 1915, Edith and Willa had traveled to the Southwest, particularly to see Mesa Verde in southern Colorado, the national park honeycombed with Anasazi ruins.

They had intended to spend only one night at Mancos, the town nearest the park, but were sufficiently enchanted to stay almost a week. Still living in Mancos was the brother of Richard Wetherill, who was the first white inhabitant of the area to have entered the mesa and seen aloft there the extraordinary cliff dwellings. Wetherill had forded the Mancos River on his horse and entered the mesa in search of lost cattle that had bolted from their pasture and swum over. As Cather writes: "Wetherill happened to glance up at the great cliffs above him, and there, through a veil of lightly falling snow, he saw, practically as it stands today, and as it had stood for eight hundred years before, the Cliff Palace . . . It stood as if it had been deserted yesterday; undisturbed and undesecrated, preserved by the dry atmosphere and by its great inaccessibility."

A not inconsiderable adventure awaited Willa and Edith on the mesa when a poor guide got them stranded and lost with night coming on. "The four or five hours that we spent waiting there," writes Edith, "were, I think, for Willa Cather the most rewarding of our whole trip to the Mesa Verde. There was a large flat rock at the mouth of Cliff Canyon, and we settled ourselves comfortably on this rock—with the idea, I believe, that we should be able to see any rattle snakes if they came racing up. We were tired and rather thirsty, but not worried, for we knew we should eventually be found. We did not

talk, but watched the long summer twilight come on, and the full moon rise up over the rim of the canyon. The place was very beautiful."

Willa wrote to Elizabeth Sergeant that she'd never learned as much in any twenty-four hours as the mesa taught her. "It's a country that drives you crazy with delight, and that's all there is to it. I can't say anything more intelligible about it." It would be years before the events of that night bore fruit in "Tom Outland's Story," the middle section of one of Cather's greatest novels, *The Professor's House*, published in 1925.

Willa and Edith proceeded from Mesa Verde to Taos, then a small and uncelebrated town, and spent a month in residence. There Cather, without knowing it, was gathering the raw materials for another of her supreme achievements, *Death Comes for the Archbishop*.

She was back in Pittsburgh on November 12, 1915, when Judge McClung, by then a widower, died. The venerated house on Murray Hill Avenue where she'd known so much happiness over the last sixteen years was promptly sold. An additional blow came when Isabelle announced, after six months of mourning her father, that she intended to marry a Jewish concert violinist named Jan Hambourg. To her friend Dorothy Canfield Fisher Willa confided: "Jan and I are not very congenial. He's a strong personality—one likes him or one doesn't. So, although Isabelle will be in New York a good

deal, things can't, of course, be as they were. It's an amazing change in one's life, you see, and on the best terms one can figure out, a devastating loss to me." Writing to her brother Roscoe she was considerably blunter: "Isabelle has married a very brilliant and perfectly poisonous Jew." Time would soften Cather's view of Jan. Still, Isabelle was the great love of her life—Edith being but the other love—and she continued for some years to regard the marriage as a personal misfortune. Eventually she and Jan would be friends. Indeed, she'd ultimately dedicate two books to him. But his presence took a lot of getting used to. The pillar of Willa's life had shifted away from her and to him. As for Edith, she never liked either Hambourg, finding them condescending to a mere advertising copywriter. They may well have been. (Edith had taken work at the J. Walter Thompson advertising agency, a job she'd hold for years.)

It was at this pass that Willa wrote two new stories, "The Bookkeeper's Wife," which she sold to *The Century Magazine*, and "The Diamond Mine," a more considerable achievement, which would be, as it turned out, her final contribution to *McClure's*. The heroine of "The Diamond Mine" is based on Lillian Nordica, another of the dramatic sopranos to whom Willa was drawn. She had died of injuries following a shipwreck off the coast of Australia. In the story, Nordica appears as Cressida Garnet—the diamond mine of the title, surrounded by

rapacious husbands and kinfolk, as was Nordica—who'll go down with the *Titanic*. "Why is it?" the heroine asks. "I have never cared about money, except to make people happy with it, and it has been the curse of my life. It has spoiled all my relations with people." The succubus on Cressida's art has been her many financial dependents. The succubus on the story is an antisemitic outburst near the end, when the loathsome sponger Miletus Poppas, Cressida's accompanist, is described thus: "He was a vulture of the vulture race, and he had the beak of one." To be sure, this must be set against positive portraits of Jews in other works—the philanthropic Nathanmeyers in *The Song of the Lark*; the cultivated Rosens in "Old Mrs. Harris"; the dashing, showy, tactless, generous Louie Marsellus in *The Professor's House*. Cather was sometimes antisemitic and—more often—philosemitic. Jews were not an obsession with her; but neither could she make up her mind about them. When the subject came up, she was sorely perplexed. This ambivalence must have expressed her divided feelings about Jan Hambourg: instinctive dislike commingled with grudging admiration. Indeed, she says in a 1931 letter to Alfred Knopf, remembering the Weiners back home in her childhood, that she "got a kind of Hebrew complex at that age, and the grand Jews still seem to me the most magnificent people on earth. They simply get me, I'm theirs. I can't refuse anything."

Six

A Painful and Peculiar Pleasure

t about the time of Isabelle's marriage, Willa and Edith began their Friday afternoon "at homes" in Bank Street, which would continue for ten or more years. Cather was, at this stage of life, not at all the recluse she later became. Poet Elinor Wylie was often present; plus old colleagues from *McClure's*; the actor George Arliss and his wife, Florence; and other Greenwich Village neighbors. Ida Tarbell sometimes appeared. But notable by their absence were any representatives of the artistic avant-garde or leftists from the milieu of *The Masses*. Their Village was not Willa's.

Meanwhile a new novel of the plains was gestating, a book

destined to increase her renown. *My Ántonia* would take the better part of three years to write. It absorbed Willa wherever she found herself: in Taos or Santa Fe; with her brother Roscoe in Wyoming; back home in Red Cloud; at rest in Bank Street.

The book begins with Cather speaking, it would seem, in propria persona, introducing her invented narrator, Jim Burden, a male double of herself—same blue eyes, same aspiring disposition, but with masculine prerogatives. Cather proposes that they write down their respective memories of a Bohemian girl named Ántonia Shimerda, the most extraordinary person of their youth. Cather dawdles, but Jim, though a busy New York lawyer who's of counsel to one of the major railroads, writes the full-length "memoir" that follows the introduction. It is a tale of *amour manqué*. Ántonia proves to be a great love that ought to have happened but did not. And yet the book's spirit, summed up in its final words, is affirmative: "Whatever we had missed, we possessed together the precious, the incommunicable past." This missed love puts to shame Jim's desperately unhappy and childless marriage.

In boyhood he slays a dragon for Ántonia, so to speak—an enormous rattlesnake they come upon at the local prairie dog town. "When I turned, he was lying in long loose waves, like the letter 'W.' He twitched and began to coil slowly. He was not merely a big snake, I thought—he was a circus monstrosity. His abominable muscularity, his loathsome, fluid mo-

tion, somehow made me sick. He was as thick as my leg, and looked as if millstones couldn't crush the disgusting vitality out of him. He lifted his hideous little head, and rattled." Jim beats the snake till it's flat. Then, in glory, he and Ántonia bear the trophy home. Such memories of childhood have meant little enough to Jim in his earlier striving years; but now they have become precious, the best evidence that he has known the fullness of life. "*Optima dies . . . prima fugit,*" the book's motto—"The best days are the soonest gone"—is also woven through the narrative. Jim comes upon it reading Virgil's *Georgics*, along with another Virgilian line dear to Cather, in which she doubtless saw herself in relation to the Divide: "*Primus ego in patriam mecum . . . deducam Musas*"—"I shall be the first, if I live, to bring the Muse into my country."

In lieu of being plotted, the book is a progress of stories united by setting. The exotically accurate evocations of the prairie can take your breath away: "It seemed as if we could hear the corn growing in the night; under the stars one caught a faint crackling in the dewy, heavily odored cornfields." And here is an electrical storm: "The thunder was loud and metallic, like the rattle of sheet iron, and the lightning broke in great zigzags across the heavens, making everything stand out and come close to us for a moment. Half the sky was checkered with black thunderheads, but all the west was luminous and clear: in the lightning flashes it looked like deep blue

water, with the sheen of moonlight on it; and the mottled part of the sky was like marble pavement, like the quai of some splendid seacoast city, doomed to destruction."

The realities of farm life—crop failures, debt, despair—are rarely offstage. At the center of the book Ántonia tells of something she has witnessed: a tramp who gives a friendly wave and flings himself headfirst into a threshing machine. As one of the hands reports, "by the time they got her stopped, he was all beat and cut to pieces. He was wedged in so tight it was a hard job to get him out, and the machine ain't never worked right since."

No one who reads *My Ántonia* forgets the tale of Russian Peter and Pavel, driven from town to town and finally out of Russia after saving themselves, the last of a wedding party, by throwing the bride to a pack of wolves that have swarmed the wedding sledges: "[T]he groom rose. Pavel knocked him over the side of the sledge and threw the girl after him. He said he never remembered exactly how he did it, or what happened afterward. Peter, crouching in the front seat, saw nothing. The first thing either of them noticed was a new sound that broke into the clear air, louder than they had ever heard it before—the bell of the monastery of their own village, ringing for early prayers."

Jim and Ántonia are haunted by the story, which they keep to themselves as a private treasure. Like all lasting tales it be-

longs to legend, to timelessness; and gives pleasure despite its savagery, as the most lasting stories do. "For Ántonia and me," says Jim, "the story of the wedding party was never at an end. We did not tell Pavel's secret to anyone, but guarded it jealously—as if the wolves of the Ukraine had gathered that night long ago, and the wedding party had been sacrificed, to give us a painful and peculiar pleasure. At night, before I went to sleep, I often found myself in a sledge drawn by three horses, dashing through a country that looked something like Nebraska and something like Virginia."

Nor does any reader forget poor traduced Ántonia delivering her own out-of-wedlock baby: "That very night, it happened. She got her cattle home, turned them into the corral, and went into the house, into her room behind the kitchen, and shut the door. There, without calling to anybody, without a groan, she lay down on the bed and bore her child." (What a painful, peculiar pleasure the scene gives.) It is with *My Ántonia*, so consecrated to memory, that Cather arrives at her deepest theme. She would have understood T. S. Eliot's remark that we live not just in the present but in the present moment of the past, past and present being the warp and weft of all experience. The lively hoard of contingent occurrences that add up to a life is infinitely to be cherished. When little Leo, one of Ántonia's many children, plays his grandfather's violin, Cather's motif of the pastness of the present and pres-

entness of the past is consummated. "In the course of twenty crowded years," says Jim, speaking for his maker, "one parts with many illusions. I did not wish to lose the early ones. Some memories are realities, and are better than anything that can ever happen to one again." *Optima dies . . . prima fugit.*

Readers recognized in *My Ántonia* a large leap forward. H. L. Mencken, the leading critic of the day, called it "not only the best done by Miss Cather herself, but also one of the best that any American has ever done . . . It is intelligent, it is moving. The means that appear in it are means perfectly adapted to its end. Its people are unquestionably real. Its background is brilliantly vivid. It has form, grace, good literary manners. In a word, it is a capital piece of writing, and it will be heard of long after the baroque balderdash now touted on the 'book pages' is forgotten."

Randolph Bourne, who'd been so astringent about *The Song of the Lark*, wrote: "Miss Cather convinces because she knows her story and carries it along with the surest touch. It has all the artistic simplicity of material that has been patiently shaped until everything irrelevant has been scraped away."

Willa was solemnly following news of the Great War. At the outset in 1914, she'd written to her editor, Ferris Greenslet (how prophetically she could not know): "I suppose they

will patch up a temporary peace and then, in twenty-five years, beat it again with a new crop of men." By the time of Germany's resumption of unrestricted submarine warfare and America's entry into the fray in April 1917, she was noting the effects on her pocketbook: "The 'high cost of living' makes our expenses here about a third more than they were last year. It takes 25 cents worth of apples to make one pie, and chickens are 42 cents a pound. A five-pound chicken costs 2 dollars, 10 cents! Beef is 36 cents, nearly as bad."

Cather's cousin G. P. Cather, son of her Aunt Franc, died in the Battle of Cantigny on May 28, 1918, America's first major European engagement. At the Armistice on November eleventh of that year she wrote from New York to condole—but also to celebrate—with Aunt Franc, as if the murderousness of history were concluded: "On this first day of the greater Peace, when this city is mad with joy and all the church bells are ringing, my heart turns to you who have helped to pay the dear price for all this world has gained. Think of it, for the first time since human society has existed on this planet, the sun rose this morning upon a world in which not one great monarchy or tyranny existed . . . I have so many letters to write to friends who have been bereaved by this terrible scourge of Influenza—but I must send you a greeting on this great day when old things are passing away forever." She is as

unprophetic here as she was prophetic four years earlier, when she'd foreseen a second world war generated out of the first. But the feeling of all that was glorious on the eleventh day of the eleventh month of 1918 gave her the initial inspiration for her next book. She would write a novel about her green-as-grass cousin G.P., dead in France for the struggle to end all wars. She was gathering impressions from the returning soldiers that her former student Albert Donovan brought to Bank Street when he came to call, as well as visiting the wounded regularly at the polyclinic.

Meanwhile, her fame had grown. Writing to her mother in December 1919 she reported on a near brush with a reporter she didn't want to indulge. "I heard a knock at the front door and didn't stir. Then a knock at the kitchen door; such a dapper young man asked if Miss Cather the Author lived here and I hesitated. 'Tell her I'm from the N. Y. Sun, and want to see her on very important business.' I told him that Miss Cather had gone to Atlantic City for a rest! I simply could not live up to the part, do you see? He left saying there was to be a big article about her on Sunday."

She felt a shift in her artistic motives and habits, and a growth in sheer confidence. To Will Owen Jones, editor of the *Nebraska State Journal*, she wrote words the wisdom of which any maturing writer will hearken to: "As one grows older one

cares less about clever writing and more about a simple and faithful representation. But to reach this, one must have gone through the period where one would die, so to speak, for the fine phrase; that is essential to learning one's business." And with professional spirits very high she wrote to brother Roscoe: "You either have to be utterly common place or else do the thing people *don't* want, because it's not yet been invented. No really new and original thing is *wanted*: people have to learn to like new things."

The new book she began to contemplate about cousin G.P. was provisionally called *Claude*. As she made her way into the material, dissatisfactions with her publisher, Houghton Mifflin, were coming to a head. She had yet to reach the mass audience she wanted, and held the company's weak advertising, marketing, and design responsible. Meanwhile, the brightest young man in American publishing, Alfred A. Knopf, had begun to court her. It was at about this time that she wrote one of her strongest stories, "Coming, Aphrodite!," to be published (after some bowdlerizing it appeared as "Coming, Eden Bower!") in Mencken's *Smart Set* in August 1920. This exceptional tale tells of two artists, a painter named Don Hedger and a soprano named Eden Bower, who find themselves in neighboring apartments on Washington Square. He is aspiring; she merely ambitious. He craves immortality; she is out for

the main chance. They are passionately mismatched. Through a knothole in the wall Don observes Eden naked at her morning exercises. Longing takes hold of him. "He slept very little, and with the first light of morning he awoke completely possessed by this woman as if he had been with her all the night before. The unconscious operations of life went on in him only to perpetuate this excitement. His brain held but one image now—vibrated, burned with it. It was a heathenish feeling; without friendliness, almost without tenderness."

None of this is good for the poor young man's art. Such emotions never are in Cather's tales of artists. "He could not know, of course, that he was merely the first to fall under a fascination which was to be disastrous to a few men and pleasantly stimulating to many thousands. Each of these two young people sensed the future, but not completely. Don Hedger knew that nothing much would ever happen to him. Eden Bower understood that to her a great deal would happen. But she did not guess that her neighbor would have more tempestuous adventures sitting in his dark studio than she would have in all the capitals of Europe, or in all the latitude of conduct she was prepared to permit herself."

Don tells her a story a Mexican priest has told him about an Aztec queen and her forty lovers. Insatiable, she pays in the end for her profligacy when her husband the king surprises

her in the act of love and kills her and that night's partner, along with the eunuch who's been arranging the assignations.

This interpolated tale neatly summarizes Cather's feelings about carnal love, as well as suggesting the prospects for a happy ending between Don and Eden. He has known the bliss of creative solitude. Now, with Eden's departure, he must suffer the misery of erotic loneliness, undermined and unmanned by love. "Knowing himself so well he could hardly believe that such a thing had happened to him, that such a woman had lain happy and contented in his arms. And now it was over." Art, not love, is the reliable bliss.

Installed at the Hotel du Quai Voltaire in the summer of 1920, just across the Seine from the Louvre, Willa was absorbing atmosphere for the next book. "Anybody would be a fool," she wrote to Blanche Knopf, "to shut themselves up with their own ideas about the city, this rather particular city, swimming in light outside. I feel very comfortable for fifty francs a day—food and lodging, that is—which is not much if you consider exchange." On July fourth she wrote to her Aunt Franc describing the parade of French war orphans carrying American flags and sporting the names of their sponsoring states. "After the parade I stopped a number of the children and greeted them and one little boy would point to himself and say 'I am Michigan,' and a little girl would say 'I

am Tex-ass.' I like to think of them and thousands more in the remote parts of France, growing up with the feeling that that flag is their friend."

A journey to one of those remoter parts was necessitated on Aunt Franc's behalf. Willa went to inspect G.P.'s grave at Villiers-Tournelle, about fifteen miles from where he fell at Cantigny. The name on the cross read "Cacher" rather than "Cather." She arranged for this to be corrected.

Seven

The Bright Face of Danger

O n January 12, 1921, Cather finally wrote to Ferris
Greenslet at Houghton Mifflin that she had decided to
leave for the newly established firm of Alfred A. Knopf, Inc.,
founded by the Columbia-educated wunderkind when he was
just out of school and promptly a magnet for remarkable tal-
ent. He'd already signed with her for one book, *Youth and the
Bright Medusa*, which gathered all the best stories about young
people and the perils of art; it had appeared in the autumn
of 1920. All her subsequent books would carry the famous
Borzoi colophon. To Dorothy Canfield Fisher, her old and
somewhat estranged friend, she wrote, taking stock of where

she'd been and now come to: "You know, better than anyone else, what a long way I had to go to get—anywhere. And you know, too, the difficulties of the road. It is strange to come at last to write with calm enjoyment and a certain ease, after such storm and struggle and shrieking forever off the key. I am able to keep the pitch now, usually, and that is the thing I'm really thankful for. But Lord—what a lot of life one uses up chasing 'bright Medusas,' doesn't one?"

Now she was free to devote herself to *Claude*, which she would publish as *One of Ours*. (The change of title was at Knopf's insistence. He felt *Claude* wasn't much of a title for a book in which he'd invested high hopes.) From conception to publication the book would consume four years of Cather's life, longer than any other work. Her cousin G.P. is transubstantiated into a Parsifal-like quester on the field of battle in France. For the first time she chose a protagonist unremarkable for anything but his pure potential, who finds fulfillment—but briefly—in a France he discovers as his true homeland. Claude Wheeler, the middle son of prosperous wheat farmers, is dangerously detached in all his daydreams, a child, Cather writes, of the moon, not the sun. "It was one of those sparkling winter nights when a boy feels that though the world is very big, he himself is bigger; that under the whole crystalline blue sky there is no one quite so warm and sentient as himself, and that all this magnificence is for him." Claude's

irreal disposition comes up against the brutal fact of a world at war, but not before coming up against the realities of life with Enid, a girl he's married when he never should have looked twice at her. Enid is preoccupied with flowers and God, with vegetarianism and anti-saloon work, with saving heathen souls in China. And she is frigid. On their wedding night, she turns Claude out of their berth on the express to Denver, forcing him to bed down as he can in the smoker. A year and a half into this marriage he is presumably still a virgin, and will die a virgin in the Argonne Forest, where the book's vivid last pages are laid.

When Enid goes to China to care for her missionary sister, Claude is left a grass widower. With little left to tie him, he decides to enlist. It is to be a baptism by fire. The troopship on which he crosses is struck with a harrowing outbreak of influenza. This section of the novel, called "The Voyage of the *Anchises*," is one of the strongest things in the book. The reader is made to feel the misery of close quarters and inedible food, as well as the terrible fear that spreads with the epidemic. The characters are strongly cut, particularly a flying ace named Victor Morse, as Midwestern as Claude but with an English accent and debonair manner that he can't have learned in Crystal Lake, Iowa. (Half-ridiculous, half-gallant, Victor will be struck over Verdun and fall a thousand feet to his death.) He tells Claude about a sweetheart in London named Maisie.

When he shows off her photo, Claude sees at once that she's old enough to be Victor's mother. It later emerges that she's an elderly prostitute who's given the poor boy syphilis. "It will really be a great thing," says Victor, "for you to meet a woman like Maisie. She'll be nice to you because you're my friend."

Claude is far indeed from the familiar world of Frankfort, Nebraska. The biggest show in human history has been underway for four years in Europe. Now he's to be in the thick of it. "History had condescended to such as he; this whole brilliant adventure had become the day's work."

France beguiles him from the start. His guide to realms unknown is David Gerhardt, a New Yorker, as cosmopolitan as Claude is ingenuous, a renowned concert violinist who's given up music to go to France, not because he thinks the war will make the world safe for democracy or end all wars—he's much too intelligent for platitudes—but because he can't bear the thought of being useless. The world he thought he knew is as gone to pieces as his beloved Stradivarius, shattered in a car collision. "I've seen so many beautiful old things smashed . . . I've become a fatalist." David (based on the life and death of violinist David Hochstein) is without illusions about what can be gained by the conflict. When Claude innocently asks him whether he thinks the Allies will get what they went in for, David says, "Absolutely not!"

It has been too little noted by critics of the novel that

Gerhardt serves Cather as a makeweight to Clyde's credulous idealism. David knows beauty and knows how destructible it is. He introduces Claude to two French families he knows well, the Jouberts and the Fleurys, models of Gallic dignity and cultivation. Both have lost sons in the fighting. Both represent for Claude a kind of perfection. He undergoes a rapid schooling in French savoir vivre. France—immemorial France, not that of the war—gives Claude a second youth: "Life had after all turned out well for him, and everything had a noble significance. The nervous tension in which he had lived for years now seemed incredible to him . . . absurd and childish, when he thought of it at all. He did not torture himself with recollections. He was beginning over again."

He is a tabula rasa on which something at last has been written. Together the idealist Claude and the realist David comprise the novel. Cather adheres resolutely to both points of view, with perhaps a shade more conviction for unwary, unsuspicious Claude who believes that ideals "were not archaic things, beautiful and impotent; they were the real sources of power among men. As long as that was true, and now he knew it was true—he had come all this way to find out—he had no quarrel with Destiny. Nor did he envy David. He would give his own adventure for no man's. On the edge of sleep it seemed to glimmer . . . like the new moon—alluring, half-averted, the bright face of danger."

Critics of *One of Ours* were sharply divided. While there were twice as many favorable as unfavorable reviews, the opinions that meant most to Cather were distinctly negative. Mencken led the way in *The Smart Set*: "What spoils the story is simply that a year or so ago a young soldier named John Dos Passos printed a novel called *Three Soldiers*. Until *Three Soldiers* is forgotten and fancy achieves the inevitable victory over fact, no war story can be written in the United States without challenging comparison with it—and no story that is less meticulously true will stand up to it. At one blast it disposed of oceans of romance and blather."

Writing in the New York *World*, Heywood Broun was brutal: "There are not more than fifty pages out of the four hundred and fifty-nine which establish any kind of spell. This is a dogged book, and we read it doggedly."

In *Vanity Fair* Edmund Wilson pronounced *One of Ours* "a pretty flat failure." At least Willa was spared Hemingway's opinion, voiced in a letter to Wilson: "Wasn't that last scene in the lines wonderful? Do you know where it came from? The battle scene in *Birth of a Nation*. I identified episode after episode. Catherized. Poor woman, she had to get her war experience somewhere." In fairness to Cather, she was not a moviegoer and her battle scenes do not resemble D. W. Griffith's.

She would have understood the moment in *A Farewell to Arms* when an embittered Frederic Henry compares the war

losses to "the stockyards at Chicago if nothing was done with the meat except to bury it. There were many words that you could not stand to hear and finally only the names of places had dignity." The slaughter for high ideals had made words like "sacrifice" and "glory" and "valor" and so on insufferable. Cather would have envied Hemingway his stockyards simile; but the keynote of her own World War I novel is not disgust but, instead, elegiac grief. Neither David nor Claude could conceivably desert like Hemingway's hero. And unlike Hemingway's hero, David and Claude are both fated to die soon, and gloriously, with all due respect to Hemingway.

In one of the book's most affecting scenes, David—whose Conservatoire classmate René Fleury has died in battle—takes up his dead friend's violin one evening at the Fleurys', and discovers he can no longer play to his satisfaction. In Cather's war novel, as in Hemingway's, many lovely things are gone. The difference between the books is one of tone, not of understanding; *A Farewell to Arms* and *One of Ours* ask to be read side by side.

About the critics who'd panned her she wrote to sister Elsie: "They insist that I could not resist the temptation to be a big bow-bow about the War. 'The other books were personal, this is external' they say!! Of course the people who are for it are just as hot, but they are rather a new crowd, not the old friends I liked to please. I always hate to lose old friends.

Well, we never get anything for nothing, in life or in art. I gained a great deal in mere technique in that book—and I lose my friends." To Elizabeth Moorhead Vermorcken, an acquaintance from Pittsburgh, she wrote: "The Pacifists have come at me like a swarm of hornets. It's disconcerting to have Claude regarded as a sentimental glorification of War, when he's so clearly a farmer boy, neither very old nor very wise. I tried to treat the War without any attempt at literalness—as if it were some war way back in history, and I was only concerned with its effect upon one boy. Very few people seem able to regard it as a story—its friends as well as its foes will have it a presentation of 'the American soldier,' whereas it's only the story of one. I wanted to call it merely 'Claude' but the publisher and everyone else was against me."

Eight

Deeper Soundings

———◆———

One *of Ours* won the Pulitzer Prize in the spring of 1923,
having sold sixteen thousand copies in the first month.
It went on to be a sustained bestseller. This was a new level of
commercial success for Cather; she would never again know
money worries. And yet she'd been deeply stung by the few
harsh reviews *One of Ours* received and would not again at-
tempt a large book. The novel démeublé would henceforth be
her profession, as she'd declared even before *One of Ours* ap-
peared.

It was a happy decision. *The Song of the Lark* and *One of
Ours*, her two big books, while interesting and moving, are

uneven. The inspiration that came to her now was for something like the opposite of those big novels of development—"a portrait like a thin miniature painted on ivory," as she put it. This would be *A Lost Lady*, whose psychological revelations ran deeper than those of its predecessors, a hauntingly beautiful tale, full of meanings evoked but not belabored, the fulfillment of the task she'd set herself in "The Novel Démeublé": "Whatever is felt upon the page without being specifically named there—that, one might say, is created. It is the inexplicable presence of the thing not named, of the overtone divined by the ear but not heard by it, the verbal mood, the emotional aura of the fact or the thing or the deed."

At forty-nine she'd come to full creative self-awareness, a new aesthetic from which she would not veer. (She'd also arrived at a level of fame necessitating a secretary, Sarah Bloom, who'd serve faithfully for the rest of Willa's life.) Critics speak of late style or style of old age: the late quartets and piano sonatas of Beethoven; the so-called black paintings of Goya or final seascapes of Turner; the water lilies of Monet or cutouts of Matisse; the last poems of Yeats or Wallace Stevens. In late style the breakthrough is to a simplified manner in which earlier preoccupations are dispensed with in favor of a new expressiveness, a new simplicity.

With *A Lost Lady* Cather arrives at a late style on which she will ring changes for the rest of her career. She famously

said that in 1922 the world broke in two. More to the point, in 1922 her career broke in two, with a long series of variously late-style works still to come and no going back to any earlier inspiration. *A Lost Lady, The Professor's House, My Mortal Enemy, Obscure Destinies, Death Comes for the Archbishop, Shadows on the Rock, Sapphira and the Slave Girl*: These works belie the valetudinarianism Cather claimed to feel at forty-nine. She had in fact the vitalistic career every creative artist dreams of—going from strength to strength into middle and old age.

While at work on *One of Ours* in the previous year, 1921, during a long stay in Toronto with the Hambourgs—relations between Jan and herself having improved markedly—she'd read of the death of Mrs. Lyra Anderson, formerly Lyra Garber, a compelling figure from her youth who'd been the beautiful, charismatic wife of a pioneer founder of Red Cloud, Silas Garber, a former governor of Nebraska. This germ worked itself out clearly in an afternoon. Before finishing *One of Ours* she knew the radically different kind of book she wanted to undertake.

Its first sentence compactly contains the whole: "Thirty or forty years ago, in one of those grey towns along the Burlington railroad, which are so much greyer today than they were then, there was a house well known from Omaha to Denver for its hospitality and for a certain charm of atmosphere." As always in Cather, there's something lost to be recaptured by

memory. Sweet Water is this time the name of the town. The novel spans thirty-seven years. The point of view is third-person intimate. When we first see Neil Herbert, the book's remembering presence, he is picnicking among friends when an older boy, the superbly named Ivy Peters—"Poison Ivy" behind his back—has maliciously trapped and blinded a bird, then released it: "The woodpecker rose in the air with a whirling, corkscrew motion, darted to the right, struck a tree-trunk,—to the left, and struck another." Neil climbs the tree to try to reach the poor creature and put it out of its misery, but falls and breaks his arm. Mrs. Forrester takes him indoors and calls the doctor. His arm mends, but the memory of Ivy's wanton cruelty stays with him, along with the glamour and mystery of the stately house's interior.

The beautiful Marian Forrester is a generation younger than her husband, Captain Forrester. A frequent guest in the gracious home, Frank Ellinger, has quietly become Marian's lover. This is indicated with supreme subtlety when the two of them say a tense goodnight: "the train of her velvet dress caught the leg of his broadcloth trousers and dragged with a friction that crackled and threw sparks."

Sex is, as so often in Cather, the worm in the apple. Young Neil, who idolizes Mrs. Forrester as if he were her *chevalier servant*, is set up for disillusionment. One morning when the Captain is away, Neil brings a bouquet of wild roses to leave

outside the French windows of Mrs. Forrester's bedroom. "As he bent to place the flowers on the sill, he heard from within a woman's soft laughter; impatient, indulgent, teasing, eager. Then another laugh very different, a man's. And it was fat and lazy,—ended in something like a yawn."

This devastating scene motivates the remainder of the book. When word reaches Marian that Ellinger is to marry a moneyed young girl in Colorado Springs, she rushes—obviously drunk—to the office of Judge Pommeroy, Neil's uncle, to place a long-distance call to her former lover. Neil is there, and when her congratulatory facade crumbles and she begins to berate Ellinger, her Lancelot, over long distance, Neil kindly cuts the cord of the telephone. He knows Mrs. Beasley, Sweet Water's "central," to be the best-supplied gossip in town and doesn't want her to overhear the pitiful tirade. Poor Mrs. Forrester shouts into the dead receiver: "You know, Frank, the truth is that you're a coward; a great hulking coward. Do you hear me? I want you to hear! . . . You've got a safe thing at last, I should think; safe and pasty! How much stock did you get with it? A big block, I hope!"

But Neil's final disillusionment comes some seasons later when it becomes clear to him that Mrs. Forrester is having an affair, in her widowhood, with none other than Ivy Peters, who has wrested away control of her land and finances. A lost lady indeed. Or is she? Neil's chivalric ideal of her is what's

lost. "It was what he most held against Mrs. Forrester; that she was not willing to immolate herself . . . and die with the pioneer period to which she belonged; that she preferred life on any terms. In the end, Neil went away without bidding her good-bye. He went away with weary contempt for her in his heart." But a contempt that cannot last. Neil has matured, knows more about life, and Marian Forrester goes on standing for the Eternal Feminine: "He came to be very glad he had known her, and that she had a hand in breaking him into life . . . Her eyes, when they laughed for a moment into one's own, seemed to promise a wild delight."

The years pass. From time to time word of her reaches Neil, her parfit gentil knyght of yore. She is in California. No, she is in Buenos Aires. She has married a rich old Englishman. She sends funds for flowers on Captain Forrester's grave each Decoration Day. And then comes word that she has left her rich old Englishman a widower. He establishes a fund to continue the flowers.

This novel represents an upheaval in Cather's thinking. She has turned against the earlier faith in ideals. Her hero Neil had wanted his lady to exemplify all the virtues. Instead she turns out to be flesh and blood, like the rest of us. With *A Lost Lady* Cather arrives not just at new dramatic mastery but at a new and deeper understanding of human nature.

Writing in *The Nation*, Joseph Wood Krutch declared that

she "can evoke by a few characteristic touches and by subtle suggestion a scene and a society without producing merely a 'document'; she can present a character without writing a psychological treatise; she can point a moral without writing a sermon; and hence she is a novelist."

Edmund Wilson praised *A Lost Lady* in *The Dial*. Writing in the New York *World*, Heywood Broun, who'd hated *One of Ours*, wrote that "Willa Cather is back from the war safe and sound. She has never done a better novel than *A Lost Lady* nor is she likely to. But then neither is any other writer of our day. This seems to us a truly great book."

F. Scott Fitzgerald would say in a letter of 1925 that he feared, writing about Daisy Buchanan in *The Great Gatsby*, to have lifted a description of Marian Forrester. Cather responded that she admired *Gatsby* and found no hint of plagiarism. But one does see the influence. Daisy is a law unto herself, like Marian. And many readers of the two books see in Neil Herbert a type of Nick Carraway.

There had been a strong caesura after *One of Ours*; it seems to have been a depression brought on by the combination of the Pulitzer and the condemnation of America's highbrow critics. Greater visibility carried with it greater potential for scorn. She was a figure to contend with. Such talents naturally win mixed reviews, though Willa's tolerance for this was small. For the first time, following *One of Ours*, she felt no

longer young; but with *A Lost Lady* she righted her ship and gained a new confidence. Having arrived at a mature—and final—style, she was now ready to write an unprecedentedly autobiographical book. True, there is the self-revelatory burden in *The Song of the Lark*. But *The Professor's House* is a far deeper sounding of herself. Professor Godfrey St. Peter's eight-volume *Spanish Adventurers* is analogous to Cather's own professional output: a first volume scarcely noticed by anyone, a second and third that fare little better.

"They had been timidly reviewed by other professors of history, in technical and educational journals. Nobody saw that he was trying to do something quite different—they merely thought that he was trying to do the usual thing, and had not succeeded very well . . . With the fourth volume he began to be aware that a few young men, scattered about the United States and England, were intensely interested in his experiment. With the fifth and sixth, they began to express their interest in lectures and in print. The two last volumes brought him a certain international reputation and what were called rewards—among them, the Oxford Prize for history."

It is not hard to graph Cather's own trajectory onto St. Peter's: laboring first in obscurity, then to greater recognition, finally winning fame and a major prize. And all of this carried out by St. Peter despite a heavy teaching load at a third-rate university in which there has been only one other professor

doing serious research, a drab little physicist named Crane. Here in this undistinguished setting is a historian on the order of Gibbon or Michelet or Parkman; Godfrey had turned down better offers because this university was near the shore of Lake Michigan, a landscape recalling the childhood from which he'd been wrenched when his family moved from their lakeside farm to the wheatlands of central Kansas; like Willa during her first year on the prairie, he'd nearly died of homesickness.

Through this milieu a comet by the name of Tom Outland has passed, leaving no one unchanged. Betrothed to St. Peter's elder daughter, Rosamond, he enlists with the Foreign Legion at the outset of the Great War and is killed in Flanders, leaving behind to Rosamond the lucrative patent for a revolutionary engine. More important, he has left behind the greatest friendship of the Professor's life, transfiguring for them both: "A man can do anything if he wishes to enough, St. Peter believed. Desire is creation, is the magical element in that process. If there were an instrument by which to measure desire, one could foretell achievement. He had been able to measure it, roughly, just once, in his student Tom Outland,— and he had foretold."

The Professor's House is a campus novel like no other. It tells the story of an orphaned young man who arrives bearing gifts for the St. Peters—earthenware vessels and rough turquoises of Anasazi provenance. And tales of adventure in the Blue Mesa

where they were found. The landscape of Professor St. Peter's *Spanish Adventurers* is a setting Tom Outland knows like the back of his hand.

When we meet him St. Peter is fifty-two years old, his heroic labors behind him, and is now at work editing for publication Tom Outland's Mesa diary. One has the sense that this is the great historian's valedictory to scholarship. As he says, he's put so much of life behind him where he can no longer go and get it. But he is Prospero-like in his equanimity facing death.

Cather had the story of Tom Outland in hand before she began *The Professor's House*. It is the middle section of that tripartite novel, the turquoise set in dull silver of the book's motto. It may be the mightiest thing she ever wrote, and she gives it a fitting home between part 1, "The Family," and part 3, "The Professor."

Some evenings, when his wife and children were away, the Professor used to invite Tom to dinner and prepare a leg of lamb, well rubbed with garlic and grilled *saignant*, with asparagus and a sparkling Asti. They'd have their supper in the garden and watch night come on. If it rained, they dined indoors. "It was on one of those rainy nights, before the fire in the dining-room, that Tom at last told the story he had always kept back. It was nothing very incriminating, nothing very remarkable; a story of youthful defeat, the sort of thing a boy is sensitive about—until he grows older."

The story is of his and his fellow cowpuncher Roddy Blake's miraculous discovery of Anasazi cliff dwellings hidden away in the recesses of the Blue Mesa. The Professor has suddenly become, by a deft feat of fiction, the young man's student; teacher and pupil have exchanged places: "In stopping to take breath," Tom tells St. Peter, "I happened to glance up at the canyon wall. I wish I could tell you what I saw there, just *as* I saw it, on that first morning, through a veil of lightly falling snow. Far up above me, a thousand feet or so, set in a deep cavern in the face of the cliff, I saw a little city of stone, asleep. It was as still as sculpture—and something like that. It all hung together, seemed to have a kind of composition: pale little houses of stone nestling close to one another, perched on top of each other, with flat roofs, narrow windows. Straight walls, and in the middle of the group, a round tower."

Visitors to Mesa Verde National Park will immediately recognize this as the massive dwelling called "Cliff House," which Cather and Edith had seen in 1915. *Ars longa*—it was a decade later that the experience bore fruit in her fiction. "I knew at once," says Tom, "that I had come upon the city of some extinct civilization, hidden away in this inaccessible mesa for centuries, preserved in the dry air and almost perpetual sunlight like a fly in amber, guarded by the cliffs and the river and the desert . . . The notion struck me like a rifle ball that this mesa had once been like a bee-hive; it was full of

little cliff-hung villages, it had been the home of a powerful tribe, a particular civilization."

Here is the essence of Cather's far-reaching humanism: a reverence for the conquest of barbarous existence by beauty-making civilization. Tom says to the Professor: "Wherever humanity has made the hardest of all starts and lifted itself out of mere brutality, is a sacred spot."

And Tom and the Professor, it turns out, had visited these sacred spots together. What the book beautifully withholds until part 3 is that Godfrey has been with Tom to the Southwest and into the mesa. "When St. Peter first began his work, he realized that his great drawback was the lack of early association, the fact that he had not spent his youth in the great dazzling Southwest country, which was the scene of his explorers' adventures. By the time he had got as far as the third volume, into his house walked a boy who had grown up there, who had imagination, with the training and insight resulting from a very curious experience; who had in his pocket the secrets which old trails tell . . ." Together they trace the routes of men dead for centuries. "Tom could take a sentence from Garces' diary and find the exact spot at which the missionary crossed the Rio Colorado on a certain Sunday in 1775. Given one pueblo, he could always find the route by which the priest had reached the next." No wonder the final volumes of *Spanish Adventurers* are an advance on the earlier ones. Tom has

provided St. Peter with a new freshness, a tactile authenticity. "It was on that trip that they went to Tom's Blue Mesa, climbed the ladder of spliced pine-trees to the Cliff City, and up to the Eagle's Nest. There they took Tom's diary from the stone cupboard where he had sealed it up years ago."

And then Tom is gone, as precipitously as he arrived. And what's left of life for the Professor is aftermath. He knows he owes the quality of his masterpiece to a self-educated boy from Pardee, New Mexico. He knows that his work is done—as husband, father, and historian. The book's title, by the end, is triply resonant. There is the elegant new house that the Professor declines to move to, the weather-beaten old house where he must remain to complete his final bit of work—and finally, the house evoked thus by Longfellow:

> For thee a house was built
> Ere thou wast born;
> For thee a mould was made
> Ere thou of woman came.

In other words, the grave: one's ultimate house, and home. He knows himself to be disengaging from all that has bound him to life: marital love, parental love, heroic research. "Lying on his old couch, he could almost believe himself in that house already. The sagging springs were like the sham upholstery

that is put in coffins. Just the equivocal American way of dealing with serious facts. Why pretend that it is possible to soften that last hard bed?"

The book received an overwhelmingly enthusiastic press. Interest in it had built from the time of its serialization in *Collier's*, beginning in June 1925, with the proceeds from which Willa bought a mink coat, the first possession of any value she had ever owned. The book would appear in September. It was understood as a study in the great-heartedness of two protagonists, a book against the grain of its time. At Mandel Hall of the University of Chicago she spoke that November on the topic "The Tendency of the Modern Novel," implicitly distinguishing herself from modernism. "There is such a thing in life as nobility," she told the capacity crowd, "and novels which celebrate it will always be the novels which are finally loved."

This did not keep her from liking one of the greatest of modernists, D. H. Lawrence, when they met through their mutual friend Mabel Dodge Luhan. Cather was finishing *The Professor's House*; Lawrence had recently published *Studies in Classic American Literature*, a book famously arguing for the instinctual, the mythical, the primitive in American works. He would likely have responded to Cather's celebration of the aboriginal yet highly civilized Anasazi, though whether he read *The Professor's House* is unknown.

Nine

This Hardihood of Spirit

———◦◦◦———

Her next book, *My Mortal Enemy*, a *nouvelle* bulked out by Knopf's production department into a book, has nothing to do with nobility. Instead, it tells the story of a battered—but true—union, and of the terrible loneliness inherent in marriage. Cather has the minimum to say about this short book in her surviving letters. The likely model for the protagonist was Hattie McClure, wife of S.S. "I knew her very well indeed," Cather writes in a letter, "and she was very much as I painted her." Myra has been disowned by a rich uncle for eloping from Parthia, Illinois, with Oswald Henshawe. The couple lead a life of luxury and mounting debt.

When the Henshawes return on a flying visit to Parthia, the book's narrator, young Nellie Birdseye (another Neil Herbert type), is captivated by their dash and glamour. They are in fact all artifice, with hairline cracks beginning to show. Nellie is still under their spell when she meets them again at their apartment on Madison Square. Cather splendidly evokes the belle-epoque setting as seen by the girl on her first trip to New York: "The snow lay in clinging folds on the bushes, and outlined every twig of every tree—a line of white upon a line of black. Madison Square Garden, new and spacious then, looked to me so light and fanciful, as Saint-Gaudens' Diana, of which Mrs. Henshawe had told me, stepped out freely and fearlessly into the grey air . . . Here, I felt, winter brought no desolation; it was tamed, like a polar bear led on a leash by a beautiful lady."

Ten years pass. Nellie encounters the Henshawes again, shorn of their panache and living hand to mouth in a shabby rooming house. The setting is now San Francisco, where Nellie has gone to make her way. She lives in the same house as the fallen Henshawes. Myra is now an invalid and Oswald her self-martyred caretaker. "Struck down by real misfortunes, poverty and illness," as Hermione Lee writes, "she plays a deposed monarch, a fallen Caesar, a medieval saint." She holds her head high; but maybe, thinks Nellie, because sensitive about a developing double chin. "Temporary eclipse" is My-

ra's jaunty gloss on their hopeless situation. The plum-colored drapes Nellie remembers from the Madison Square apartment now hang faded and worn. She recognizes other things made precious by memory: the rugs, the pictures in their peeling frames, the little inlaid tea table. "While I told her," says Nellie, "any amusing gossip I could remember about my family, she sat crippled but powerful in her brilliant wrappings. She looked strong and broken, generous and tyrannical, a witty and rather wicked old woman who hated life for its defeats, and loved it for its absurdities. I recalled her angry laugh, and how she had always greeted shock or sorrow with that dry, exultant chuckle which seemed to say: 'Ah-ha, I have one more piece of evidence, one more, against the hideous injustice God permits in this world!'"

Nellie watches Myra's steep decline, and hears her grim wisdom: "'People can be lovers and enemies at the same time, you know. We were ... A man and a woman draw apart from that long embrace, and see what they have done to each other. Perhaps I can't forgive him for the harm I did him.'" Myra even seems to cast her husband of so many years as her mortal enemy. It is, says Nellie, the most terrible judgment she's ever heard on all that one hopes for. "Why must I die like this, alone with my mortal enemy?" asks Myra, in desolation. But it is not just Oswald but also herself she's declaring to be her mortal enemy. Herself and all her vanity: "Violent natures

like hers sometimes turn against themselves . . . against themselves and all their idolatries." She dies heroically and in penance. Father Fay, the young priest who comes to give the sacrament, wonders whether she might be something like the saints of the early Church. In an immense final effort she seems to have made peace with her shadow-self, her mortal enemy, and manages to get to a headland where she can watch the coming of day one last time. But for Nellie there is no peace. "Sometimes," she says, "when I have watched the bright beginning of a love story, when I have seen a common feeling exalted into beauty by imagination, generosity, and the flaming courage of youth, I have heard again that strange complaint breathed by a dying woman into the stillness of night, like a confession of the soul: 'Why must I die like this, alone with my mortal enemy?'" The little book is a tale of disenchantment, like *A Lost Lady*; but darker, less forgiving of human nature. It seems a nadir in Cather's powers of affirmation—but near the zenith of her artistry.

Critics were sharply divided. In the *Chicago Tribune*, Fanny Butcher called it "a masterpiece of tragedy" and "a great book." Writing in *The Nation*, Joseph Wood Krutch said: "Events are seen frankly through the haze of distance; the thing immediately present is not these events themselves but the mind in which they are recollected; and the effect is, therefore, not the vividness and harshness of drama but something almost

elegiac in its softness." But in the *New York Times* Louis Kro-
nenberger panned the book under the caption "Willa Cather
Fumbles for Another Lost Lady." Rightly or not, it has re-
mained in *A Lost Lady*'s shadow and is among the least loved
and least typical of her books. In my opinion, as I say, it is one
of her best. Had it appeared as a story in a collection rather
than as a too-slender volume, people would have regarded it
as a major work.

In any case, she was about to turn her hand to something
everyone would declare a masterpiece among masterpieces,
Death Comes for the Archbishop. Stints of writing back in Red
Cloud; at the Jaffrey Inn in Jaffrey, New Hampshire; on
Grand Manan Island in the Bay of Fundy; at the MacDowell
Colony in Peterborough, New Hampshire; and of course in
her alcove at the apartment on Bank Street brought the book
rapidly into being. Never had she labored with more confi-
dence and clarity of purpose. She nimbly thought her way
back to nineteenth-century New Mexico; and this first his-
torical novel pleased her sufficiently that she would write
two more: *Shadows on the Rock*, which takes place in late-
seventeenth-century Quebec, and *Sapphira and the Slave Girl*,
laid in antebellum Virginia. Feeling more and more out of
phase with her time, Cather found in historical fiction a con-
soling refuge and fresh idiom. She would finish the *Archbishop*
in the autumn of 1926 and see it through serialization in *The*

Forum between January and June. Knopf's handsome edition appeared in September.

Cather had for many years been noting down hints and suggestions for a novel about the Southwest, her adopted landscape. Then it came to her in a flash: It was to center on the nineteenth-century priests who came to New Mexico to restore a Catholicism degraded by priestly concubinage and other outrages to the faith. She took her cue from an obscurely published book by Father William Howlett, *Life of the Right Reverend Joseph P. Machebeuf, D.D.* "At last," writes Cather in her open letter on the *Archbishop*, printed in the Catholic magazine *Commonweal*, "I found out what I wanted to know about how the country and the people of New Mexico seemed to those first missionary priests from France. Without these letters in Father Howlett's book to guide me, I would certainly never have dared to write my book." Machebeuf becomes her Father Joseph Vaillant, vicar general of the diocese of New Mexico. Father Jean-Baptiste Lamy, who brought order to Santa Fe, becomes the book's hero, Archbishop Jean Marie Latour. Richly embroidered with inset tales (in the tradition of Cervantes) and passionate evocations of the uncanny Southwestern landscape, the novel tells of the friendship between these two men, sons of the Auvergne and friends from childhood, devoted to the same professionalism, the same piety. And each the chief event in the other's life. "To attempt

to convey this hardihood of spirit" was her aim, as she says in the *Commonweal* letter. They are Archbishop and Vicar General, superior and subordinate. Yet the emotion of friendship makes equals of them—as friendship does. Educated Frenchmen, they would know Montaigne's irreducible and unsurpassable characterization of the beauty of friendship: "Because it was he, because it was I." Add to this that the two missionaries are probable saints and you have the formula for the book.

Catholic critic Michael Williams wrote in *Commonweal*, reviewing the *Archbishop*: "Her book is wonderful proof of the power of a true artist to penetrate and understand and to express things not a part of the equipment of the artist as a person. Miss Cather is not a Catholic, yet certainly no Catholic American writer that I know of has ever written so many pages so steeped in spiritual knowledge and understanding of Catholic motives and so sympathetically illustrative of the wonder and beauty of Catholic mysteries, as she has done in this book." Indeed, the *Archbishop* is something entirely new and strongly sacramental with its intimations of eternity. The descriptive ardor serves a God-haunted purpose: every temporal thing beheld by the light of the divine. Cather and her entire family had been received into the Episcopal Church in 1922. With the *Archbishop* she makes herself an honorary Catholic; for the rest of her life she'd be mistaken for a Catholic

born and bred, with the treasury of medieval sainthood at her fingertips. "I had all my life wanted to do something in the style of legend," she writes, "which is absolutely the reverse of dramatic treatment. Since I first saw the Puvis de Chavannes frescoes of the life of Saint Genevieve in my student days, I have wished that I could try something a little like that in prose; something without accent, with none of the artificial elements of composition. In the Golden Legend"—a thirteenth-century compendium—"the martyrdoms of the saints are no more dwelt upon than are the trivial incidents of their lives; it is as though all human experiences, measured against one supreme spiritual experience, were of about the same importance. The essence of such writing is not to hold the note, not to use an incident for all there is in it—but to touch and pass on."

She'd found a medieval method for telling a nineteenth-century story; and preferred to call the book a narrative rather than a novel. Everything is sharply in focus in both the human and the natural scene. Nothing is too humble to draw Cather's powers of description. Here, for instance, are wild pumpkins: "It is a vine, remarkable for its tendency, not to spread and ramble, but to mass and mount. Its long, sharp, arrow-shaped leaves, frosted over with prickly silver, are thrust upward and crowded together; the whole rigid, up-thrust matted clump

looks less like a plant than like a great colony of grey-green lizards, moving and suddenly arrested by fear."

Everywhere, God is in the details. Cather's new artistry is at home with the divine omnipresence. Here is a grove of cottonwoods belonging simultaneously to time and timelessness: "They grew far apart, and their strange twisted shapes must have come about from the ceaseless winds that bent them to the east, and scoured them with sand, and from the fact that they lived with very little water,—the river was nearly dry here for most of the year. The trees rose out of the ground at a slant, and forty or fifty feet above the earth all these white, dry trunks changed their direction, grew back over their base line. Some split into great forks which arched down almost to the ground; some did not fork at all, but the main trunk dipped downward in a strong curve, as if drawn by a bow-string."

Last, there is this sublime apparition: "At one moment the whole flock of doves caught the light in such a way that they all became invisible at once, dissolved in light and disappeared as salt dissolves in water. The next moment they flashed around, black and silver against the sun."

Such are a few of the "amazing sensory achievements" Rebecca West saluted in her *New York Times* review of the book. By such disclosures of the miraculous in the ordinary, of eternity in time, Cather discovers her own "natural super-

naturalism," to adapt a phrase from an early passion of hers, Carlyle. Hers is the true note: Bishop Latour says to Father Vaillant, "Where there is great love there are always miracles . . . One might almost say that an apparition is human vision corrected by divine love. I do not see you as you really are, Joseph; I see you through my affection for you." He goes on to say to his friend that the miracles of the Church are but a correction of our vision "so that for a moment our eyes can see and our ears can hear what is about us always." This Romantic seeing into the life of things is Cather's original religion— neither Episcopalian nor Catholic but entirely her own—in which art and faith are finally one (as Godfrey St. Peter had declared in *The Professor's House*). The union of the two is epitomized by the Midi Romanesque church that Bishop Lamy decreed and built at Santa Fe, known to all visitors, and the same monument to God that Bishop Latour builds in the novel.

Death finds a willing quarry when he comes for the Archbishop. The old priest's face is turned to eternity; he is reveling in the simultaneous presence of all phases of his life, all within reach and all comprehensible—a pilgrim soul as amenable to death as he has been avid of life. Those attending him "thought his mind was failing; but it was only extraordinarily active in some other part of the great picture of his life." His

final thoughts are of his extraordinary friend from boyhood, Father Vaillant—often absent, always dearest.

In middle age Cather arrived at a tranquil belief in God and an enjoyment of religion. She felt sorry for unbelievers, classing them with vegetarians, pacifists, and other crackpots. She attended the Anglican mass wherever she was, but most notably at the Church of the Ascension in Greenwich Village. On wakeful nights she'd recite the Nicene Creed; it rarely failed to calm her. And though Episcopalian, she had a strong admiration for the rich medievalism of the Roman Catholic Church. It was this admiration that made her most virtuosic—some would say greatest—novel possible. Cather's was a case of religion in the root sense of the word: *re-ligare*, to be bound back to. Tom Outland says he has read of filial piety in the Latin poets. Filial piety: being bound back in reverence to the past, to some intimation of timelessness within history—some incarnation. Every human situation worth writing about was for Cather an intersection of time and eternity. Thus in practice her art and her religion were indissoluble.

two other brownstones were to be pulled down to make way for an apartment building (the same that can be seen on the corner of Bank and West Eleventh today). Willa and Edith moved to the Grosvenor Hotel at 35 Fifth Avenue, opposite the Church of the Ascension. Intended as temporary, this makeshift would last five cramped and uncomfortable years, and be Willa's inducement for spending less time in New York in favor of Jaffrey, Grand Manan, Quebec, and Paris; also in Red Cloud, where Mr. Cather's situation was worsening. That Willa chose to remain in New York at all was surely owing to Edith's position at J. Walter Thompson. Still, they were frequently apart in these years, particularly as Edith never accompanied Willa to Red Cloud. Would the connubial nature of their attachment have been too obvious if she had? Probably.

Mr. Cather died of a heart attack on March third. Willa caught the next train out of New York for the funeral and stayed on for several weeks. One of her foremost stories, "Neighbour Rosicky," germinated from this grief. In it, a Bohemian farmer who has lived well makes his arrangements with death—makes friends, as Freud would say, with the necessity of dying. He is a man at home in his skin who looks forward without fear to the change that nature must imminently make. He is the husband of a good woman, the father of fine children. The Rosickys are a family who haven't much beyond what they need, but are clearly possessed of the secret

Ten

Things Unguessed At
and Unforeseeable

———◆———

Nineteen twenty-seven would be a year of trials as we
as triumphs. That summer Charles Cather, Willa's fa
ther, suffered a severe attack of angina, the harbinger of wors
to come. Willa cut short a stay in the Bighorn Mountains o
Wyoming in order to be with him at Red Cloud. Back in New
York, she and Edith faced the loss of their cherished apart-
ment on Bank Street. The IND had been cutting through a
new subway line nearby, making the neighborhood much less
pleasant. Then it was announced that No. 5 Bank Street and

of living. In "Neighbour Rosicky" Cather brings off a particular feat—a story entirely about happiness.

Rosicky stops one day to admire the cemetery at the edge of his own land: "It was a nice graveyard, Rosicky reflected, sort of snug and homelike, not cramped or mournful,—a big sweep all around it. A man could lie down in the long grass and see the complete arch of the sky over him." Not overanxious to leave the good things fortune has favored him with, he is nonetheless ready to contemplate the peace of joining the other residents of the little graveyard. The story, beautifully managed throughout, ends as it must. Rosicky sits down to do a little patching. "After he had taken a few stitches, the cramp began in his chest, like yesterday. He put his pipe cautiously down on the window-sill and bent over to ease the pull. No use,—he had better try to get to his bed if he could. He rose and groped his way across the familiar floor, which was rising and falling like the deck of a ship." Thus he goes; his loved ones bury him, just where he wished to be. Born in Bohemia, young in London and New York, middle-aged and old in Nebraska, Rosicky has lived through all the four seasons of life and come to rest here in "this little square of long grass which the wind forever stirred . . . Nothing could be more undeathlike than this place; nothing could be more right for a man who had helped to do the work of great cities and had always longed for the open country and had got to it at last."

Charles Cather's death was the first major loss of Willa's life. She was fifty-three. "Neighbour Rosicky" was her monument to him.

Alone in the old house, she'd given herself over to renovations—as arduous a job as writing a book, she said. "I've got such lovely silk curtains up in the dining room," she wrote to her mother, away in California. "My little old bed is painted primrose color like the washstand,—I mean the wooden bed that was in the west room." She saw to the repapering of the bedrooms and parlor, set out new shrubs in the yard. "We had to do a good deal of plastering," she wrote to Roscoe, "as most of the sitting room ceiling fell down. These messy repairs could never have been made with Mother here—it would have fretted her to death. I'm awful pleased with the results, and I've seldom spent money that I enjoyed so much." So much time alone in the old house seems to have been her way of mourning.

Three years earlier she'd purchased a parcel of land on Grand Manan Island in the Bay of Fundy, where she and Edith had lived in a series of rented summer bungalows since 1921. Tired of the challenge each year of finding new lodgings, Cather decided to have a cottage built for herself and Edith. In the summer of 1928 they took up residence there. It was primitive living, without indoor plumbing or electricity or a telephone. They took their meals at a nearby guesthouse

called Whale Cove. An attic room reminiscent of the one back in Red Cloud, and the one back in Pittsburgh, served Willa nicely as her studio. Along the top of the nearby cliff overlooking the bay was a trail on which she took her afternoon constitutional after the ironclad hours of writing. As Woodress writes: "The cabin modestly squatted on a tiny clearing between a tall spruce wood and the sea,—sat about fifty yards back from the edge of the red sandstone cliff which dropped . . . to a narrow beach—so narrow that it was covered at high tide." Such was the rugged paradise where Willa and Edith would spend summers together.

The two had made the regular journey there in June 1928, after Willa received an honorary degree from Columbia University. (Other honorary degrees would shortly follow from Yale, Princeton, and Berkeley.) Rather than by way of Boston, they traveled to Montreal, then Quebec City, then Saint John, New Brunswick, where they caught the ferry for Grand Manan. This annual experience of French-speaking Canada was proving consequential. The idea for a new book was beginning to take shape. If this northern landscape did not act on her with the same force as that of the Southwest, she still had her immense probity to fall back on. Thus it was to be a novel of rock-set Quebec in the years 1697–98. If *Shadows on the Rock*, "this bashful volume," as she called it, remains permanently in the shadow of the *Archbishop*, it has many

attractive features—the setting of the scene, the revolution of the seasons—and rises to remarkable distinction in its latter half.

In December 1929 her mother suffered a paralytic stroke while visiting Douglass in Long Beach, California. Cather hurried by train to her side, appalled to discover on arrival that Mrs. Cather could no longer speak. She would subsequently be moved to Las Encinas Sanitarium at Pasadena, where she continued her inexorable decline. Mrs. Cather would not see Red Cloud again.

Coming to hard birth amid these fresh sorrows was *Shadows on the Rock*, with its inset tales framed by the story of a widower-apothecary, Euclide Auclair, and his gentle daughter, Cécile, on the rock of Quebec. Though not a long book, it would consume four years from inception to publication. Cather was working with her usual eloquence, but one senses at half pressure.

She was no respecter of her own dictum that all worthwhile writing comes from the author's early experience. The *Archbishop* had been the refutation of that. She was a mature woman before she discovered the American Southwest, and deep in middle age before she discovered, more or less by accident, French Canada. Yet *Shadows on the Rock*, so hushed and slow-moving, is a deep response, a declaration of religious piety in the face of middle-aged losses. If it lacks both the pictorial and narrative splendor of *Death Comes for the Archbishop*, it has the

qualities of a spiritual summing-up. Though unlikely to be anyone's favorite Cather, it has an inevitable place in the sequence of her books. She is down to fundamentals when she writes it. And tired; and haunted by the accumulating losses. As she wrote to Dorothy Canfield Fisher in September 1930: "[T]hese vanishings, that come one after another, have such an impoverishing effect upon those of us who are left—our world suddenly becomes diminished—the landmarks disappear and all the splendid distances behind us close up. These losses, one after another, make one feel as if one were going on in a play after most of the principal characters are dead."

A powerful metaphor. Another powerful metaphor, discovered in *Death Comes for the Archbishop*, was coming to her aid as she wrote *Shadows*. The Acoma tribe had built their city on the Enchanted Mesa: "The rock, when one came to think of it, was the utmost expression of human need; even mere feeling yearned for it; it was the highest comparison of loyalty in love and friendship. Christ himself had used that comparison for the disciple to whom He gave the keys of His Church." The shadow-play of human striving, desperation, and occasional glory is all of it cast against some abiding reality, some adamant that knows no change. The rock remains, we pass by. *Shadows* is her most sacramental book. To believe was no delusion, according to Cather; to believe was a gift, a gift she possessed in addition to her others. Religion she saw

as the utmost expression of human need; that it might be delusion was a point of view she wanted nothing to do with.

Reviewers of *Shadows* were underwhelmed. Louis Kronenberger, by now an old foe, wrote in *The Bookman*: "There is no blood in it, no muscle, no bodily emotion . . . it is commonplace flavored with lavender, domesticity without domestic strife, old Quebec swept clean and fresh by human hands, but unpeopled by human beings." This and other negative reviews must have hurt despite enormous sales— 160,000 copies in the first four months alone, one of the bestselling books of 1931. Almost immediately on publication in August, word reached Cather at Grand Manan that her mother had died in Pasadena. To Dorothy Canfield Fisher she wrote: "The end was sudden—pneumonia. I shall stay on here through September and then I must go to my poor brother who has lived solely for his mother for three years and a half. I feel a good deal like a ghost, and I know it is worse for him." Having been unable to attend the funeral gnawed at her. She would belatedly get to Red Cloud in time for Christmas, but with both parents now gone this would be, as it turned out, her final visit "home," as she always called Red Cloud. Here she evokes the Divide in another letter to Dorothy Canfield Fisher, writing of "the certainty of countless miles of empty country and open sky and wind and night on every side of me. It's the happiest feeling I ever have. And when I am most

enjoying the lovely things the world is full of, it's then I am most homesick for just that emptiness and that untainted air."

As with the sudden death of the father, so with the invalidism and death of the mother: Grief engendered an exceptional story, this time "Old Mrs. Harris," Cather's fullest portrait of the household in which she'd grown up. This time the iteration of Red Cloud is a place called Skyline, Colorado. The Templeton household is crowded with growing children and a newborn; a father who seems to slip away in time of need; a vain selfish Southern darling of a mother, Victoria; a bound Black girl who's come west with the family and waits on them selflessly; and a maternal grandmother, Old Mrs. Harris— based on Willa's maternal grandmother, Rachel Boak—who serves the family as a drudge-of-all-work, as if she too were bound labor. Next door lives an upstanding, cultivated, childless couple, the Rosens, Jews who are especially solicitous of the ambitious eldest Templeton child, Vickie, full of curiosity about the Rosens' books and music and engravings. "Of course no other house in Skyline was in the least like Mrs. Rosen's; it was the nearest thing to an art gallery and a museum that the Templetons had ever seen."

Vickie is free to treat the Rosens' bookshelves as a lending library. She is *moralement partie*, as the French call it. She has morally departed, is already, mentally, somewhere bigger and more gratifying. It is a matter of the utmost urgency for her to

gain the scholarship to Ann Arbor she has put in for. "She never asked herself, as she walked up and down under the cottonwoods on those summer nights, what she would do if she didn't get the scholarship. There was no alternative. If she didn't get it then everything was over." Having got the scholarship, it is of the utmost urgency for her to make up the three-hundred-dollar shortfall, which the Rosens philanthropically agree to cover.

Meanwhile the grandmother, Old Mrs. Harris, who sleeps in a corridor on a mattress without springs, with Mrs. Rosen's gift of a sweater to keep her company, is declining. Her daughter is too self-involved to care, like the rest of the household. And Vickie? *Moralement partie.* "Wasn't it just like them all to go and get sick, when she had now only two weeks to get ready for school, and no trunk and no clothes or anything?" Can't they see that her whole young life hangs by a thread? "What were families for, anyway?"

Such is the invincible selfishness of youth. But Cather tells the story from a long way off. A mature consciousness revisits the scene of youthful heedlessness. When you're along in age and can look back on the callousness and headlong self-involvement of youth and *cringe*, then you're getting somewhere, *moralement.* Mrs. Harris dies, of course, making as little fuss in death as she has in life. Vickie has still to go on, "to follow the long road that leads through things unguessed

at and unforeseeable," among which is the discovery that the young are destined one day to be as callous to her as in her own youth she'd been to Grandma. "I was heartless because I was young and strong and wanted things so much. But now I know." On that hard lesson the story snaps shut.

A Kind of Golden Light

O ld Mrs. Harris" and "Neighbour Rosicky," along with "Two Friends," a briefer story about the foundering of a friendship at the time of the 1896 presidential election, were gathered together into a book aptly called *Obscure Destinies*, published by Knopf in August 1932. It was in December that the belated move from cramped quarters at the Grosvenor to a spacious flat at 570 Park Avenue took place. This would be the final move. It was at this apartment, with its south-facing windows and ample light, that Willa would spend the rest of her days when in New York.

At about this time she wrote to a younger friend, the playwright Zoë Akins: "It's a brutal fact, Zoe, that after one is 45, it simply rains death, all about one, and after you've passed fifty, the storm grows fiercer. I never open the morning paper without seeing the death of someone I used to know, East or West, staring me in the face." And yet, she avers in the same letter, a "kind of golden light comes as a compensation for many losses. You'll see!"

In 1933 Cather won the Prix Femina Américaine and received an honorary degree from Smith College. Buoyed by these distinctions, and by the remarkable commercial success of *Shadows*, she began work on a tenth novel, *Lucy Gayheart*. It is a retreat from historical fiction back into the early inspiration that produced *The Song of the Lark*. Music is its obbligato—the structure is musical, as are the characters. If a lesser book than *The Song of the Lark*, *Lucy Gayheart* yet has its peculiar charm. Where Thea Kronborg is a genius, driven to the heights by sublime inner necessity, Lucy is simply a girl hoping to scratch out a living as an accompanist and teacher. "We missed Lucy in Haverford"—this time Red Cloud is called Haverford—"when she went away to Chicago to study music. She was eighteen years old then; talented but too careless and light-hearted to take herself very seriously. She never dreamed of a 'career.'"

As well, Lucy is unlike Thea in that she is made for love.

Love, not music, is her highest value. For which she is martyred—exactly the fate Thea knows how to avoid. Lucy has escaped the small-town trammels and found work and study under Professor Auerbach, a Viennese-born teacher of piano in Chicago. He introduces her to the esteemed baritone Clement Sebastian, and she stands in for him as accompanist while James Mockford—his limping, green-eyed, mincing regular accompanist—recuperates in preparation for a surgery. As so often in Cather, the villain announces himself immediately by his physical traits, and is boundless in his malevolence. Mockford and Lucy instantly recognize each other as natural enemies and competitors for Sebastian's love.

She forgets all about her suitor back home, Harry Gordon, even going to the extreme of telling him she has made love with Sebastian, which is not true. It may be the only scene in literature where a young girl tells this particular lie. As it turns out, she has sealed her fate by doing so. Sebastian will be drowned in a boating accident on Lake Como, along with Mockford—clinging to the end, for he is unable to swim and pulls Sebastian down with him. Shattered by this news, Lucy returns to Haverford, where she does not escape the tittle-tattle of the town gossips. When she sees Harry Gordon, he is cool and ironical with her. She resolves to return to Chicago, and makes the fatal decision to go ice skating one last time on the Platte.

But the night is too cold and so she resolves to hitch a ride from the first passerby, who happens to be Harry. He refuses her even this courtesy, and rides off. She puts on her skates and heads out onto what she thinks are the shallows. Unknown to her, the river has shifted its bed since last spring's flood; she skates onto the main river where the ice is thin, falls through, and drowns. All of this is handled with Cather's best economy and vividness: "Without looking or thinking she struck toward the center for smoother ice. A soft, splitting sound brought her to herself in a flash, and she saw dark lines running in the ice about her. She turned sharply, but the cracks ran ahead of her." She plunges in to the waist, still unafraid, still not knowing it's the river itself beneath her. "She was groping cautiously with her feet when she felt herself gripped from underneath. Her skate had caught in the fork of a submerged tree, half buried in the sand by the spring flood. The ice cake slipped from under her arms and let her down."

When Harry Gordon returns from over the hill, sleigh bells singing, he overtakes a train of lanterns and wagons toiling across the frozen land. The search party sent out for Lucy has discovered her body and is bearing her back to town. Harry's remorse is instant and "a life sentence," as he calls it. Another of Cather's unhappily married men, he knows that the life he should have had was with Lucy, whom he has all but killed. A quarter century has passed, and offered no respite:

"Kingdoms had gone down and the old beliefs of men had been shattered since that day when he refused Lucy Gayheart a courtesy he wouldn't have refused to the most worthless old loafer in town."

In one of Cather's characteristic codas, summing up and resolving the story a quarter of a century later, we learn from the anonymous narrator about an early memory of Harry's. He had watched Lucy step lightly across wet concrete as a thirteen-year-old girl, leaving faint footprints behind her. The old Gayheart house has been sold and the rest of the family—father and sister—have now joined Lucy and her long-dead mother in the cemetery. The little footprints are for Harry the essence of lost love. Always on her way, always darting, always in flight. "As he was leaving the Gayhearts', he paused mechanically on the sidewalk, as he had done so many thousand times, to look at the three light footprints, running away."

The book is, with "The Sculptor's Funeral," Cather's harshest verdict on small-town life; you might think of it as the obverse of *My Ántonia*, in which Black Hawk is a place to be held dear in memory. Haverford is just a backwater to get out of. It was perhaps no accident that she'd made her final farewell to Red Cloud before writing *Lucy*. As for the book itself, it seems to have pleased Cather less than it did most of the critics. She wrote to Zoë Akins in August 1933 that it was

about a silly girl with whom she'd lost patience. "At any rate, it does not put me in a holiday mood as some books have done." Her refuge was the rose- and hollyhock-covered cottage on Grand Manan. The year was 1934 and this was the first time she'd not felt renewed by work on a book. Meanwhile, *Lucy Gayheart* had been serialized in *Woman's Home Companion* between March and July and published in book form by Knopf in August.

When it appeared Granville Hicks, still in his Marxist youth, published "The Case against Willa Cather" in the *English Journal*, in which he charged her with "supine romanticism" and a failure to confront the mounting crises of the age. In a word, the allegation was weak-minded escapism, flight from the actualities. She would reply in the pages of *Commonweal* as follows: "When the world is in a bad way, we are told, it is the business of the composer and the poet, to devote himself to propaganda, and fan the flames of indignation." Her own view is that art—"an unaccountable predilection of the one unaccountable thing in man"—acquires its singular value by being useless. It outlasts its original contexts and goes on flourishing after the social, economic, and political circumstances that gave rise to it have changed.

Willa found the embodiment of everything she cherished in a teenage boy, Yehudi Menuhin, having befriended him

and his family of Lithuanian-American Jews in Paris in 1930. The young violinist's virtuosity became a touchstone. When they'd met through the Hambourgs he was a fourteen-year-old who'd already been on the stages of America and Europe for seven years. The attachment between the two was immediate and lasting. The boy and his sisters, Yaltah and Hephzibah, adored "Aunt Willa." These children, all of them musically gifted, were as dear to her as her own nieces and nephews, she liked to say. It seems that Willa's philo-Semitism (a current alternating with its opposite) got activated by the Menuhins; they stood for civilization itself. Watching these children grow was one of her constant joys. Twice a week all three would cross Central Park from their residence on the Upper West Side to read Shakespeare aloud with Aunt Willa and Miss Lewis. They began with *Richard II* and went on to *Macbeth* and *Henry IV*. These occasions were pure delight for the precocious children. On April 22, 1934, Yehudi crossed the park for his sleigh, kept at Aunt Willa's, and invited her to go sledding in Central Park. This they did in celebration of the young man's eighteenth birthday, then came home to 570 for lunch.

In his autobiography, *Unfinished Journey*, Menuhin writes: "She was a rock of strength and sweetness. Ever since coming east she had reserved time during the week for walking in

Central Park, which was to her native Nebraska as a nosegay to an interminable prairie. Her favorite walk was around the reservoir in the park, where contact with the earth renewed her sense of belonging in a metropolis in which so much conspired to alienation. Park veterans ourselves, my sisters and I often joined her, taking turns at the honor of walking by her side."

One of her constant worries in these years had been Isabelle's declining health. Much of the motive for travel to Toronto or Paris had been to be near her as much as possible. Isabelle remained first in Willa's affections. Her long decline due to chronic kidney disease was an unremitting sorrow. Jan had returned to the recital stage to try to raise badly needed funds for her care. It was this that took them to Chicago—where Jan had contracted to give master classes at the Bush Conservatory—with Willa along to nurse Isabelle. At the age of sixty-two, she'd found something more urgent than writing.

On the Hambourgs' return to Europe, Willa was determined to have some time with Edith, perhaps as compensation. They booked passage on the *Rex* to Italy, which she'd not visited since that long-ago journey of 1908. These months of 1935 had been among the hardest of her life. What she and Edith wanted, after a stay in the Dolomites, was three weeks of wandering Venice, which Willa deemed the world's most

ravishing city. From Venice, she returned to Paris to rejoin the Hambourgs for two months and Edith returned to New York. Willa's solitary journey home was stormy, but she had always reveled in rough crossings. While others lay prostrate and green below, she loved striding the decks and breathing the salt air.

Twelve

If We Had Our Lives
to Live Over Again

⸺◈⸺

Willa and Edith spent the summer of 1936 on Grand
Manan entertaining Willa's nieces, Mary Virginia
Auld and Margaret and Elizabeth, Roscoe's twin daughters.
Willa was beginning preparations for Houghton Mifflin's
twelve-volume uniform edition of her books. Was this meant
to be along the lines of Scribner's New York Edition of the
works of Henry James? Probably. The paper was a rich vel-
lum, the bindings handsome, the typeface excellent. A life's
work, beautifully summed up; the set gave her status as a liv-
ing classic. In November Knopf brought out a collection of

Cather's best essays and essay-memoirs, polemically entitled *Not Under Forty*, meaning that she'd taken her stand with the old world, the pre-1922 world, and the "forward-goers" would find nothing worthwhile in her book. This anti-modernist declaration was something every reviewer seized on, either by way of praise or blame. She stood for the old high things, said some. She was lost in escapist antiquarianism, said others.

It was probably at about this time that she formed the plan of writing a novel laid in antebellum Virginia, the world of her great-grandparents and grandparents. In the spring of 1938 she and Edith visited this landscape of her childhood— Winchester and Back Creek and Willow Shade, the old family house. As Edith writes: "Every bud and leaf and flower seemed to speak to her with a peculiar poignancy, every slope of the land, every fence and wall, rock and stream . . . The country-side was very much changed. But she refused to look at its appearance; she looked through and through it, as if it were transparent, to what she knew as its reality. Willowshade, her old home . . . had become so ruinous and forlorn that she did not go into it, only stood and looked down on it from a distance. All these transformations, instead of disheartening her, seemed to light a fierce inner flame that illuminated all her pictures from the past." That flame would be used for smelting *Sapphira and the Slave Girl*.

In June 1938 Douglass Cather, Willa's brother, died sud-

denly in California at the age of fifty-eight. To their sister Elsie, Willa wrote: "Nothing in my life has ever hit me so hard. Father's death and Mother's seemed natural. They had lived out their lives, but this seems unnatural altogether, and I cannot get used to it or feel reconciled to it. Anyone so full of the joy of life, and so full of energy and hope—no, I can't seem to accept it at all. A good deal of the time I cannot believe it's true." At the hour of the service for him in California, she went alone to the Catholic Church of St. Vincent Ferrer near her New York apartment and prayed.

Four months later came another blow. Isabelle McClung Hambourg lost her long battle with kidney disease. She and Jan had been staying at the Hotel Cocumella at Sorrento when she took a turn for the worse. Jan wrote to Willa as follows: "During nearly five days I watched her strong, loyal and loving heart resist death. Not more than half a dozen times did her face show anguish or anxiety, then only for a few minutes. She slept as though under the influence of a potent anesthetic. As she died her face took on a perfectly calm remote look. After three hours her lips shaped into a gentle gracious smile." Willa wrote to her sister Margaret that such friendships as hers with Isabelle occur but once in a lifetime and that one does not want to replace such a presence with any other. "We brought each other up. We kept on doing that all our lives . . . As long as she lived, her youth and mine were

realities to both of us." The two of them exchanged not fewer than three hundred letters over the years; Isabelle kept Willa's with her wherever she went, to reread at her leisure. After Isabelle's death Jan returned the letters to Willa, who burned them all in the fireplace at 570 Park Avenue. Only two inconsequential notes have somehow survived.

Cather finished *Sapphira* amid the shocking news of the fall of France in June 1940. What she'd always regarded as a second homeland had gone under. She wrote to Zoë Akins that "the heritage of all the ages is being threatened." She followed the war with anguish, particularly the Battle of Britain that followed. Churchill was her embodiment of Periclean heroism. It was at this time that she befriended Sigrid Undset, the famed Norwegian writer and refugee from the Nazis, also a Knopf author, whose elder son, a lieutenant in the Norwegian Army, had died in the early days of the war. She liked Undset's work and, more important, regarded her as an embodiment of the European values Nazism was laying to waste.

Yet another Knopf author, Wallace Stevens, had read *Sapphira* when it was sent to him, and wrote to a friend: "Miss Cather is rather a specialty. You may not like the book; moreover, you may think she is more or less formless. Nevertheless, we have nothing better than she is. She takes so much pains to conceal her sophistication that it is easy to miss her quality." A part of her quality in *Sapphira*, as always, is in the

minutely particularized world of nature. Here she is in her best descriptive vein: "From out the naked grey wood the dogwood thrust its crooked forks starred with white blossoms— the flowers set in their own wild way along the rampant zigzag branches . . . In all the rich flowering and blushing and blooming of a Virginia spring, the scentless dogwood is the wildest thing and yet the most austere, the most unearthly." To Ferris Greenslet she wrote: "The rush of Virginia memories, when once I began to call them up, was heavy upon me. I wrote many chapters of Virginia ways and manners, just as things came back to me, for the relief of remembering them in a time of loss and personal sorrow. That 'eased' me, and comforted."

Sapphira Dodderidge Colbert may be the novel's principal character, but Abolition is the book's true hero. Few readers forget the phantasm and portent at the center of the narrative—six years after the enactment of the Fugitive Slave Law and five before the advent of Civil War—of a wise old Quaker: "This man, though now seventy, firmly believed that . . . the Lord had already chosen His heralds and His captains, and a morning would break when all the black slaves would be free." Rachel Colbert Blake, Sapphira and Henry's widowed daughter—based closely on Cather's grandmother Rachel Elizabeth Seibert Boak—arranges for the underground railroad to spirit Nancy, the slave girl, across the Potomac to

a safe house in Pennsylvania and onward by a series of Aboli-
tionist hideouts to the safety of Montreal, secure from slave-
catchers. About Rachel, one of Cather's noblest creations, she
writes: "A feeling long smothered had blazed up in her—had
become a conviction. She had never heard the thing said be-
fore, never put into words. It was the owning that was wrong,
the relation itself, no matter how convenient or agreeable it
might be for master or servant." Rachel has recruited herself
to the sacred cause, closing ranks with Postmistress Bywaters
and Reverend Fairhead to break the law by aiding and abet-
ting the underground railroad. "The severe Fugitive Slave
Law," writes Cather, "passed six years ago, had by no means
prevented slaves from running away. Its very injustice had
created new sympathizers for fugitives, and opened new ave-
nues of escape. From as far away as Louisiana, negroes were
now reaching Canada; the railroads and the lake steamboats
helped them. If a negro once got into Pennsylvania or Ohio,
he seldom failed to go through."

The six or eight slaves at the Colberts' house and their mill
are Sapphira's "property," the evidence that she had taken a
step down by marrying a miller. Her husband is quietly Abo-
litionist, and deliberately leaves in a coat pocket the money
necessary for Rachel to facilitate Nancy's flight. Having coldly
portrayed Sapphira's motives throughout the book, Cather
relents at the end and grants her and Henry a rare moment

of accord. "We would all do better," she says to him, "if we had our lives to live over again." In one of Cather's characteristic epilogues, as mentioned in chapter 1, Nancy returns to Back Creek and the Shenandoah Valley twenty-five years later, a dignified woman in her prime, and we learn everything that has happened in the intervening time: the marriages, the departures, the misadventures—above all, of course, the deaths.

Sapphira enjoyed exceptional sales and received excellent reviews. The Book of the Month Club bought the book for January 1941 and ordered more than two hundred thousand copies. Henry Canby wrote in the *Saturday Review of Literature* that Cather was not "writing a melodrama of slavery and seduction, but recreating, with subtle selection of incident, a society and a culture and a sociology in which a conflict of morals and of philosophies produces an inner, ever more tightly coiled spring."

Willa had now written all of her novels. There were fitful stabs at a long story to be called "Hard Punishments," laid in fourteenth-century Avignon. The protagonists are a boy with hands deformed from being hung by his thumbs for theft and a boy whose tongue has been cut out for blasphemy. What she did with this premise is hard to know, for Willa left instructions with Edith, ever loyal unto the letter, to destroy all unfinished manuscripts. Only a few pages miraculously survive

and are housed today at the University of Virginia Special Collections.

She was experiencing the relation of past to present differently, and could best express it to someone who'd shared her youth. In March 1941 she wrote to Carrie Miner Sherwood, among her dearest childhood friends: "[I]t is strange how, at this end of the road, everything is foreshortened, and we seem to possess all the stages of our life at the same time." Like the Archbishop, she was seated in the middle of her experience, all of it within reach.

Thirteen

Leave-Takings

———◆———

In July 1942 Willa had her gallbladder and appendix re-
moved. While the surgery was successful, she would never
regain her former vigor. In October she journeyed for a rest
to Williamstown, Massachusetts, and—under cover of a pseu-
donym, "Winifred Carter"—checked into the Williams Inn.
Nonetheless she was recognized, while inspecting the stained
glass of the Williams College chapel, by an undergraduate who
shyly asked, "Are you Willa Cather?" She describes the scene
in a letter to one of her nieces: "He asked if I were not I in such
a nice way that I admitted it."

The old restlessness and drive to travel were still there. But

she refused to fly, indeed was never in her life aboard an airplane. What she loved was trains. Here is a bravura passage from her last completed story, "The Best Years": "On Saturdays the children were allowed to go down to the depot to see the Seventeen come in. It was a fine sight on winter nights. Sometimes the great locomotive used to sweep in armored in ice and snow, breathing fire like a dragon, its great red eye shooting a blinding beam along the white roadbed and shining wet rails. When it stopped, it panted like a great beast. After it was watered by the big hose from the overhead tank, it seemed to draw long deep breaths, ready to charge afresh over the great Western land."

But the capacity for such exuberance was leaving her. In a bleak mood Cather wrote to Sigrid Undset on December 25, 1943: "This is such a terrible Christmas—it seems like a preparation for horrors unexampled and unguessed at." A month later she summed up the diminishments in a letter to Harriet Fox Whicher: "When all family relations are broken up, and so many friends of mine don't even know where their husbands or sons are, the result seems to be that nothing in our life is very real at any time. There is the scramble for food, and one reads the war news: that's about all." A month after that there is this to Viola Roseboro' concerning "that beautiful old world we thought would last forever." Why, she asks, should splendid cities a thousand years in the making now

suddenly tumble down? "Why on earth do we, in all the countless stretch of years, just in our little moment, have to witness everything laid waste?"

Yet some of the old pleasures managed to sustain her. One indelible evening was spent with Yehudi in February 1944 at a performance of *Othello* starring Paul Robeson and Uta Hagen. Robeson she'd already met at the Menuhins'. His performance as Othello, the first by a Black man with a white cast, had been stellar; but the revelation of the evening was Uta Hagen: "The fact is she is not lovely at all—a rather lame, peaked, starved little thing . . . But her beautiful conception of the part is so strong that it shines through her, like a candle through a horn globe. And she grows lovelier with every act, until the last terrible one."

In May of that year she attended the annual ceremonial of the American Academy of Arts and Letters to receive their Gold Medal for Fiction. On the dais with her was a gnarled and shrunken S. S. McClure, himself there to receive the Academy's Order of Merit. When the award was made Willa could not help herself; she rose and crossed the stage to embrace her old boss—"the man who gave me my first chance," as she liked to say.

Willa wrote most of "The Best Years" in Northeast Harbor, Mount Desert, Maine—at the Asticou Inn, where she and Edith had summered during the war years, Grand Manan

being inaccessible for the duration. Shortly after completing the story—written for her brother Roscoe—word came from California that he had died of a heart attack in his sleep. Another devastation. To his widow, Meta Schaper Cather, she wrote: "Roscoe was the only one of my family who felt about things as I did . . . The fact is that now I have no one to judge me, no one to tell me if I am off the true pitch—no other judgment that I care a bang about." To Roscoe's daughters, her adored nieces Virginia, Margaret, and Elizabeth, she wrote: "Your father was always . . . my soundest and best critic. I used to think he knew the inside of my head better than I did."

Her health declined further. Severe tendonitis was forcing her to wear an immobilizing brace on her right hand and arm. Writing had become all but impossible, and dictation of serious work was always out of the question. She'd written to Carrie Miner Sherwood, her childhood friend: "Of course I can't dictate my own work—I have to see the picture shape itself on the page before me—the sound of my own voice would make me self-conscious. But I dictate all my letters, even those to old and dear friends." Willa was in decline and knew it; she'd come to see life as a series of unbearable good-byes, and lived clinched against the next devastating blow. In the Line-a-Day she kept sporadically at this time, "very tired" and "deathly tired" are typical entries. Additional strain resulted from her determination to dictate responses to the sol-

diers and sailors who'd read her books in the special Armed Forces Editions and written to thank her. While she was inclined in these years to say no to most everything—no to all requests to adapt books for stage or screen or radio, no to Viking's proposal of a Portable Cather, no to all interviews—she felt an obligation to the men at arms she heard from almost daily and made it a priority to dictate responses to them.

On the other hand, her response to a Professor Carl J. Weber of Colby College was blunt. She begged for no more queries about her sources, meetings, inspirations, and creative process. "After all," she tersely wrote, "this is not a case for the Federal Bureau of Investigation." She concluded the letter with a preposterous lie, and slammed the door: "I am leaving for Mexico City within a few days, and this is an opportune time to bring our correspondence to a close." Whenever Willa wished to fend someone off, she would say she was going to Mexico City, a place she never in her life visited.

The major achievement of these difficult years was, as I say, her story called "The Best Years," written that summer of 1945 for Roscoe ("I can't bear to look at it now"). Published only posthumously, it situates us once again in Red Cloud, this time called MacAlpin, and the familiar loft of her blossoming adolescence (her "rose bower," on account of the red and brown roses of the attic wallpaper) is again featured. The story returned Cather—evoking a revered teacher, Mrs. Evangeline

King Case—to her original powers. A big bustling family, the Ferguessons, is dominated by boys and an elder sister, Lesley. "Their upstairs was a long attic which ran the whole length of the house, from the front door downstairs to the kitchen at the back. Its great charm was that it was unlined. No plaster, no beaver-board lining; just the roof shingles, supported by long, unplaned, splintery rafters that sloped from the sharp roof-peak down to the floor of the attic." This registration of place is hallucinatory; we are back there with her. "Experiences were many. Perhaps the most exciting was when the driving, sleety snowstorms came on winter nights. The roof shingles were old and had curled under hot summer suns. In a driving snowstorm the frozen flakes sifted in through all those little cracks, sprinkled the beds, and the children, melted on their faces, in their hair! That was delightful. The rest of you was snug and warm under blankets and comforters, with a hot brick at one's feet."

At Mrs. Ferguesson's insistence, a little sanctum has been partitioned off over the kitchen end of the loft for her daughter. Thus in Cather's last bow as a writer we come upon her start: the safekeeping of an attic room full of unmeasurable potential and with everything still to do.

In her next-to-last letter to Roscoe she had written, in July 1945, about the old rose bower: "Do you remember? I can always work best in a low room under the roof. All my books

were written in Jaffrey, N. H. in a little room where I could almost touch the ceiling with my hand. I feel afraid in a big room. I like to be snug."

With fewer than two years to live, she seems in "The Best Years" to be taking a last inventory. As she writes to Irene Miner Weisz in October 1945: "Now I know that nothing really matters to us but the people we love. Of course, if we realized that when we are young, and just sat down and loved each other, the beds would not get made and very little of the world's work ever get done." She ventured out less and less. She might go to lunch at Sherry's and then to look in on the pictures of the Frick Collection. Or to change her books at the New York Society Library on East Seventy-Ninth Street. But travel was now out of the question. And seeing people had become exhausting to her; any social effort was debilitating. Still, she would leave the apartment one last evening—to hear Yehudi play at Carnegie Hall.

She remained in bed on the morning of April 24, 1947, rousing herself for lunch with Edith, then returning to her room, complaining of a headache. Her secretary, Sarah Bloom, followed in case Willa wished to dictate something. Then death came for her. She suffered a massive cerebral hemorrhage. Edith writes in her memoir: "She was never more herself than on the last morning of her life—the morning April 24th, 1947. Her spirit was as high, her grasp of reality as firm as always.

And she had kept that warmth of heart, that youthful, fiery generosity which life so often burns out." Four days later she was interred at Jaffrey, within sight of Monadnock. It was a view she had loved and been inspired by over the years. She was at rest now, done with chasing bright Medusas. Edith lived on and on, a loving widow and fierce guardian. She died in 1972 and is also buried in Jaffrey, at the foot of Willa Cather's grave.

Acknowledgments

I am grateful to Tracy Tucker at the National Willa Cather Center in Red Cloud for numerous good offices. Josh Caster at the Archives and Special Collections of the University of Nebraska at Lincoln was patient with my many requests. Hermione Lee gave generously of her time and immense expertise. Maggie Simmons and Michael Korda read an early version of the book and were wonderfully encouraging. My agent, Wendy Strothman, has been exemplary, even when I was not. At Penguin Random House I benefited from the unfailing professionalism of Paloma Ruiz and Isabelle Alexander. My sharp-eyed copy editor, Sheila Moody, saved me often from myself. To my editor, Patrick Nolan, go heartfelt thanks I cannot properly register here. The feeling runs too deep.

Notes

PROLOGUE

2 "There is no God but one God": Willa Cather, *The Selected Letters of Willa Cather*, ed. Andrew Jewell and Janis Stout (New York: Alfred A. Knopf, 2013), 39.

2 "There was nothing but land": Willa Cather, *My Ántonia* (Boston: Houghton Mifflin, 1918), 8.

4 "a place where refugees": Willa Cather, *The Song of the Lark* (Boston: Houghton Mifflin, 1915), 202.

4 "instinctive standards": Cather, *Song of the Lark*, 241.

4 "If all the great 'loyalties'": Cather, *Selected Letters*, 468.

4 "All my stories": Willa Cather, *Stories, Poems, and Other Writings* (New York: Library of America, 1992), 995.

5 "hard bit by new ideas": Cather, *Selected Letters*, 156.

5 "I feel as if my mind": Cather, *Selected Letters*, 161.

5 "Happiness is something": Willa Cather, *The Professor's House* (New York: Alfred A. Knopf, 1925), 228.

6 "the long road": Willa Cather, *Obscure Destinies* (New York: Vintage, 1974), 190.

6 "the world broke": Willa Cather, *Not Under Forty* (New York: Alfred A. Knopf, 1936), v.

8 "He sat in the middle": Willa Cather, *Death Comes for the Archbishop* (New York: Alfred A. Knopf, 1927), 288.

8 "If only I could nail": Cather, *Death Comes for the Archbishop*, 185.

9 "The dead call to us": Richard Holmes, *This Long Pursuit* (New York: Pantheon, 2016), 257–58.

10 "'I have been her admirer'": See Alice Munro, "Dulse," in *The Moons of Jupiter* (New York: Alfred A. Knopf, 1983), 39, 58.

CHAPTER ONE: TO A DESERT PLACE

12 The moral mutilation: See Toni Morrison, *Playing in the Dark: Whiteness and the Literary Imagination* (New York: Vintage Books, 1993), 18–28.

12 "In this book": Cather, *Selected Letters*, 613.

13 "A man could plow a straight furrow": James Woodress, *Willa Cather: A Literary Life* (Lincoln: University of Nebraska Press, 1987), 32.

14 "The land did it": Willa Cather, *O Pioneers!* (Boston: Houghton Mifflin, 1913), 116.

14 "In the newest part of the New World": Woodress, *Willa Cather*, 334.

15 "as naked as the back of your hand": Willa Cather, *Willa Cather in Person: Interviews, Speeches, and Letters*, ed. L. Brent Bohlke (Lincoln: University of Nebraska Press, 1986), 32.

15 "We had very few American": Willa Cather, *The Kingdom of Art: Willa Cather's First Principles and Critical Statements, 1893–1896*, ed. Bernice Slote (Lincoln: University of Nebraska Press, 1967), 448.

16 "One realizes": Cather, *Not Under Forty*, 136.

17 "she was accompanying him": Edith Lewis, *Willa Cather Living: A Personal Record* (New York: Alfred A. Knopf, 1953), 22–23.

18 "Her rapid footsteps": Cather, *My Ántonia*, 148.

18 "Since investigation": Woodress, *Willa Cather*, 61.

CHAPTER TWO: OUTSPOKENNESS

21 "There was an atmosphere of endeavor": Cather, *My Ántonia*, 258.

22 "Up to that time": Cather, *Selected Letters*, 391.

22 "very florid and full": Woodress, *Willa Cather*, 73.

22 "He was proud": Woodress, *Willa Cather*, 73.

23 "God a second time": Cather, *Kingdom of Art*, 426.

25 "It is manifestly unfair": Cather, *Selected Letters*, 17.

25 "It is a good thing": Cather, *Selected Letters*, 23.

26 "Suppose I were an apple grower": Cather, *Selected Letters*, 555–56.

CHAPTER THREE: YEARS OF FRENZY

28 "Of Maurel's singing": Willa Cather, *The World and the Parish: Willa Cather's Articles and Reviews, 1893–1902*, ed. William Curtin (Lincoln: University of Nebraska Press, 1970), vol. 1, 180.

28 "In a generation when fiction": Cather, *World and the Parish*, vol. 1, 136.

29 "The author of 'Helas'": Cather, *World and the Parish*, vol. 1, 265.

29 "not only lacks": Cather, *World and the Parish*, vol. 1, 393–94.

30 "I have not much faith": Cather, *World and the Parish*, vol. 1, 276–77.

31 "profound melancholy": Cather, *World and the Parish*, vol. 1, 774.

31 "I have never known": Cather, *World and the Parish*, vol. 1, 776.

31 "One could hang about": Cather, *My Ántonia*, 212–20.

32 "There were departments": E. K. Brown, *Willa Cather: A Critical Biography* (New York: Alfred A. Knopf, 1953), 78.

33 "Frau Gadski who sings": Cather, *World and the Parish*, vol. 1, 404.

36 "I have been in England": Cather, *World and the Parish*, vol. 2, 890–91.

36 "The remoteness, the unchangedness": Cather, *World and the Parish*, vol. 2, 897.

37 "Time and again": Cather, *World and the Parish*, vol. 2, 908.

37 "Certainly so small": Cather, *World and the Parish*, vol. 2, 921.

37 "The interior is vested": Cather, *World and the Parish*, vol. 2, 923–24.

38 "a well-fed self-satisfied bourgeois town": Cather, *World and the Parish*, vol. 2, 923.

38 "There is a rue Balzac": Cather, *World and the Parish*, vol. 2, 929.

38 "not one of your clear": Cather, *World and the Parish*, vol. 2, 947.

39 "I had a continual restless feeling": Cather, *World and the Parish*, vol. 2, 947.

CHAPTER FOUR: THE BIG CLEAN UP-GRADE

42 "I heard a quick-drawn breath": Willa Cather, *Collected Stories* (New York: Vintage Classics, 1992), 195.

43 "I came back here": Cather, *Collected Stories*, 210.

44 "His eyes were remarkable": Cather, *Collected Stories*, 209.

44 "I once had in my Latin": Cather, *Selected Letters*, 614.

44 "On Sunday morning": Cather, *Collected Stories*, 186.

44 "He would show himself": Cather, *Collected Stories*, 189.

45 "a collection of freak stories": Woodress, *Willa Cather*, 179.

46 *"Dear Boys and Girls"*: Cather, *Selected Letters*, 92–93.

49 "an atmosphere in which": Cather, *Not Under Forty*, 58, 63.

50 "I sit there": Cather, *Selected Letters*, 110.

50 "Seven hundred years ago": Cather, *Selected Letters*, 111.

50 "reading so much poorly written": Cather, *Selected Letters*, 118.

51 "I have not a reportorial mind": Cather, *Selected Letters*, 119.

52 "When one is far away": Cather, *Selected Letters*, 126.

54 "[I]t is not always easy": Willa Cather, *Alexander's Bridge* (Boston: Houghton Mifflin, 1912), preface, vii–viii.

54 "something was out of line": Cather, *Alexander's Bridge*, 115.

55 "There were other bridge-builders": Cather, *Alexander's Bridge*, 10.

55 "I always used to feel": Cather, *Alexander's Bridge*, 13.

55 "supposed to be more engaging": Katherine Anne Porter, "Reflections on Willa Cather," in *The Collected Essays* (New York: Delacorte Press, 1970), 36.

56 "I went for six months": Willa Cather, *On Writing: Critical Studies on Writing as an Art* (New York: Alfred A. Knopf, 1949), 92.

56 "the great fact": Cather, *O Pioneers!*, 15.

56 "There are only two": Cather, *O Pioneers!*, 119.

57 "The shapes and scenes": Cather, *On Writing*, 48.

57 "Do you feel at peace": Cather, *O Pioneers!*, 308.

58 "The sureness of feeling": Woodress, *Willa Cather*, 240.

CHAPTER FIVE: BREAKING FREE

59 "You cannot go a block": Cather, *Selected Letters*, 132.

61 "I tell you": Cather, *Selected Letters*, 199.

61 "The novel, for a long while": Cather, *Not Under Forty*, 43.

61 "In the end of the wing": Cather, *Song of the Lark*, 53–54.

62 "that sturdy little companion": Cather, *Song of the Lark*, 145.

62 "she had an appointment": Cather, *Song of the Lark*, 199.

62 "All the houses": Cather, *Song of the Lark*, 371.

63 "The stream and the broken pottery": Cather, *Song of the Lark*, 378.

63 "All these things": Cather, *Song of the Lark*, 280.

63 "Perfectly hideous!": Cather, *Song of the Lark*, 290.

64 "Who marries who": Cather, *Song of the Lark*, 412.

64 "What I want to do": Cather, *Selected Letters*, 329.

65 "It was his wife's custom": Cather, *Song of the Lark*, 40.

66 "You seem to have liked": Cather, *Selected Letters*, 215.

67 "Wetherill happened to": *Book News Monthly* (January 1916), 214.

67 "The four or five hours": Lewis, *Willa Cather Living*, 97.

68 "It's a country that drives you": Cather, *Selected Letters*, 209.

68 "Jan and I": Cather, *Selected Letters*, 219.

69 "Isabelle has married": Cather, *Selected Letters*, 226.

70 "Why is it?": Woodress, *Willa Cather*, 280.

70 "He was a vulture": Cather, *Collected Stories*, 107.

70 "got a kind of Hebrew complex": Cather, *Selected Letters*, 444.

CHAPTER SIX: A PAINFUL AND PECULIAR PLEASURE

72 "Whatever we had missed": Cather, *My Ántonia*, 372.

72 "When I turned": Cather, *My Ántonia*, 45–46.

73 "It seemed as if": Cather, *My Ántonia*, 137.

73 "The thunder was loud": Cather, *My Ántonia*, 139.

74 "by the time they got her stopped": Cather, *My Ántonia*, 178.

74 "[T]he groom rose": Cather, *My Ántonia*, 59.

75 "For Ántonia and me": Cather, *My Ántonia*, 61.

75 "That very night": Cather, *My Ántonia*, 316.

76 "In the course of": Cather, *My Ántonia*, 328.

76 "not only the best": H. L. Mencken, *H. L. Mencken on American Literature* (Athens: Ohio University Press, 2002), 76.

76 "Miss Cather convinces": Woodress, *Willa Cather*, 301.

76 "I suppose they will": Cather, *Selected Letters*, 198.

77 "The 'high cost of living'": Cather, *Selected Letters*, 234.

77 "On this first day": Cather, *Selected Letters*, 260.

78 "I heard a knock": Cather, *Selected Letters*, 282.

78 "As one grows older": Cather, *Selected Letters*, 278.

79 "You either have to be": Cather, *Selected Letters*, 263.

80 "He slept very little": Cather, *Collected Stories*, 74.

80 "He could not know": Cather, *Collected Stories*, 81.

81 "Knowing himself so well": Cather, *Collected Stories*, 99.

81 "Anybody would be a fool": Cather, *Selected Letters*, 292.

81 "After the parade": Cather, *Selected Letters*, 293.

CHAPTER SEVEN: THE BRIGHT FACE OF DANGER

84 "You know, better": Cather, *Selected Letters*, 299.

84 "It was one of those sparkling": Willa Cather, *One of Ours* (New York: Alfred A. Knopf, 1922), 87.

86 "It will really be a great": Cather, *One of Ours*, 249.

86 "History had condescended": Cather, *One of Ours*, 252.

86 "I've seen so many beautiful": Cather, *One of Ours*, 330.

87 "Life had after all": Cather, *One of Ours*, 332.

87 "were not archaic things": Cather, *One of Ours*, 339.

88 "What spoils the story": Woodress, *Willa Cather*, 333.

88 "There are not more than fifty": Woodress, *Willa Cather*, 333.

88 "a pretty flat failure": Woodress, *Willa Cather*, 333.

88 "Wasn't that last scene": Woodress, *Willa Cather*, 333.

89 "They insist that I could not": Cather, *Selected Letters*, 324.

90 "The Pacifists have": Cather, *Selected Letters*, 325.

CHAPTER EIGHT: DEEPER SOUNDINGS

92 "a portrait like": Cather, *Willa Cather in Person*, 77.

92 "Whatever is felt": Cather, *Not Under Forty*, 50.

93 "Thirty or forty years": Willa Cather, *A Lost Lady* (New York: Alfred A. Knopf, 1923), 9.

94 "The woodpecker rose": Cather, *A Lost Lady*, 24.

94 "the train of her velvet dress": Cather, *A Lost Lady*, 60.

95 "As he bent to place the flowers": Cather, *A Lost Lady*, 86.

95 "You know, Frank": Cather, *A Lost Lady*, 134.

96 "It was what he most held": Cather, *A Lost Lady*, 169.

96 "He came to be very glad": Cather, *A Lost Lady*, 171.

97 "can evoke by a few": Woodress, *Willa Cather*, 351.

97 "Willa Cather is back": Woodress, *Willa Cather*, 351.

98 "They had been timidly": Cather, *The Professor's House*, 22.

99 "A man can do anything": Cather, *The Professor's House*, 19–20.

100 "It was on one of those": Cather, *The Professor's House*, 155.

101 "In stopping to take breath": Cather, *The Professor's House*, 179–80.

101 "I knew at once": Cather, *The Professor's House*, 180.

102 "Wherever humanity": Cather, *The Professor's House*, 199.

102 "When St. Peter first began": Cather, *The Professor's House*, 234–35.

103 "It was on that trip": Cather, *The Professor's House*, 235.

103 "Lying on his old couch": Cather, *The Professor's House*, 248.

104 "There is such a thing": Woodress, *Willa Cather*, 378.

CHAPTER NINE: THIS HARDIHOOD OF SPIRIT

105 "I knew her very well": Cather, *Selected Letters*, 579.

106 "The snow lay in clinging folds": Willa Cather, *My Mortal Enemy* (New York: Vintage Classics, 1990), 25.

106 "Struck down": Hermione Lee, *Willa Cather: Double Lives* (New York: Pantheon Books, 1989), 216.

107 "While I told her": Cather, *My Mortal Enemy*, 65.

107 "'People can be lovers'": Cather, *My Mortal Enemy*, 88.

107 "Violent natures": Cather, *My Mortal Enemy*, 96.

108 "when I have watched": Cather, *My Mortal Enemy*, 104–5.

108 "a masterpiece of tragedy": Woodress, *Willa Cather*, 388.

108 "Events are seen": Woodress, *Willa Cather*, 388.

110 "I found out what I wanted": Cather, *On Writing*, 8.

111 "Her book is wonderful proof": *Commonweal*, September 28, 1927, 491–92.

112 "I had all my life wanted": Cather, *On Writing*, 9.

112 "It is a vine": Cather, *Death Comes for the Archbishop*, 88.

113 "They grew far apart": Cather, *Death Comes for the Archbishop*, 221–22.

113 "At one moment": Cather, *Death Comes for the Archbishop*, 209.

113 "amazing sensory achievements": Lee, *Willa Cather: Double Lives*, 272.

114 "Where there is great love": Cather, *Death Comes for the Archbishop*, 50.

114 "thought his mind was failing": Cather, *Death Comes for the Archbishop*, 288.

CHAPTER TEN: THINGS UNGUESSED AT
AND UNFORESEEABLE

119 "It was a nice graveyard": Cather, *Collected Stories*, 237.

119 "After he had taken a few": Cather, *Collected Stories*, 260.

119 "this little square": Cather, *Collected Stories*, 261.

120 "I've got such lovely": Cather, *Selected Letters*, 407.

120 "We had to do a good deal": Cather, *Selected Letters*, 407.

121 "The cabin modestly squatted": Woodress, *Willa Cather*, 145.

123 "[T]hese vanishings": Cather, *Selected Letters*, 433.

123 "The rock, when one came": Woodress, *Willa Cather*, 427.

124 "There is no blood": Woodress, *Willa Cather*, 433.

124 "The end was sudden": Cather, *Selected Letters*, 452.

124 "the certainty of countless miles": Cather, *Selected Letters*, 484.

125 "Of course no other house": Cather, *Collected Stories*, 274.

126 "She never asked herself": Cather, *Collected Stories*, 297.

126 "Wasn't it just": Cather, *Collected Stories*, 311.

126 "to follow the long road": Cather, *Collected Stories*, 313–14.

CHAPTER ELEVEN: A KIND OF GOLDEN LIGHT

130 "It's a brutal fact": Cather, *Selected Letters*, 474.

130 "We missed Lucy in Haverford": Willa Cather, *Lucy Gayheart* (New York: Alfred A. Knopf, 1935), 5.

132 "Without looking or thinking": Cather, *Lucy Gayheart*, 198–99.

133 "Kingdoms had gone down": Cather, *Lucy Gayheart*, 220.

133 "As he was leaving": Cather, *Lucy Gayheart*, 231.

134 "At any rate": Cather, *Selected Letters*, 489.

134 "supine romanticism": Woodress, *Willa Cather*, 469.

134 "When the world is": Woodress, *Willa Cather*, 469.

135 "She was a rock": Woodress, *Willa Cather*, 454.

CHAPTER TWELVE: IF WE HAD OUR
LIVES TO LIVE OVER AGAIN

140 "Every bud and leaf": Lewis, *Willa Cather Living*, 182.

141 "Nothing in my life": Cather, *Selected Letters*, 548.

141 "During nearly five days": Cather, *Selected Letters*, 558.

141 "We brought each other up": Cather, *Selected Letters*, 562.

142 "the heritage of all the ages": Cather, *Selected Letters*, 580.

142 "Miss Cather is rather": Wallace Stevens, *Letters of Wallace Stevens*, ed. Holly Stevens (New York: Alfred A. Knopf), 381.

143 "From out the naked": Willa Cather, *Sapphira and the Slave Girl* (New York: Alfred A. Knopf, 1940), 15–16.

143 "The rush of Virginia": Cather, *Selected Letters*, 593.

143 "This man, though now seventy": Cather, *Sapphira and the Slave Girl*, 111–12.

144 "A feeling long smothered": Cather, *Sapphira and the Slave Girl*, 137.

144 "The severe Fugitive Slave Law": Cather, *Sapphira and the Slave Girl*, 222–23.

145 "We would all do better": Cather, *Sapphira and the Slave Girl*, 269.

145 "writing a melodrama": *Saturday Review of Literature* (December 14, 1940), 5.

146 "[I]t is strange how, at this end": Cather, *Selected Letters*, 601.

CHAPTER THIRTEEN: LEAVE-TAKINGS

147 "He asked if I were not I": Cather, *Selected Letters*, 612.

148 "On Saturdays the children": Cather, *Collected Stories*, 382.

148 "This is such a terrible": Cather, *Selected Letters*, 623.

148 "When all family relations": Cather, *Selected Letters*, 630.

148 "that beautiful old world": Cather, *Selected Letters*, 631.

149 "The fact is she is not": Cather, *Selected Letters*, 633.

150 "Roscoe was the only one": Cather, *Selected Letters*, 653.

150 "Your father was always": Cather, *Selected Letters*, 654–55.

150 "Of course I can't dictate": Cather, *Selected Letters*, 646.

151 "this is not a case": Cather, *Selected Letters*, 644.

151 "I can't bear": Cather, *Selected Letters*, 653.

152 "Their upstairs was": Cather, *Collected Stories*, 381.

152 "Do you remember?": Cather, *Selected Letters*, 651.

153 "Now I know that nothing": Cather, *Selected Letters*, 627.

153 "She was never more herself": Lewis, *Willa Cather Living*, 197.

Bibliography

Author's Note: While *My Ántonia* and *Death Comes for the Archbishop* will always be Cather's two best-loved books, there are other ways of beginning with her. My own recommendation is to start with her great phase of the early to mid-1920s: *A Lost Lady* and *The Professor's House* show Cather at her most searching—and modern, though she would not have used that word to describe herself. Her books, in chronological order, are as follows:

April Twilights. Boston: Richard G. Badger, 1903.

The Troll Garden. New York: McClure, Phillips, 1905.

Alexander's Bridge. Boston: Houghton Mifflin, 1912.

O Pioneers! Boston: Houghton Mifflin, 1913.

The Song of the Lark. Boston: Houghton Mifflin, 1915.

My Ántonia. Boston: Houghton Mifflin, 1918.

Youth and the Bright Medusa. New York: Alfred A. Knopf, 1920.

One of Ours. New York: Alfred A. Knopf, 1922.

A Lost Lady. New York: Alfred A. Knopf, 1923.

April Twilights and Other Poems. Alfred A. Knopf, 1923.

The Professor's House. New York: Alfred A. Knopf, 1925.

My Mortal Enemy. Alfred A. Knopf, 1926.

Death Comes for the Archbishop. New York: Alfred A. Knopf, 1927.

Shadows on the Rock. New York: Alfred A. Knopf, 1931.

Obscure Destinies. Alfred A Knopf, 1932.

Lucy Gayheart. New York: Alfred A. Knopf, 1935.

Not Under Forty. New York: Alfred A. Knopf, 1936.

Sapphira and the Slave Girl. New York: Alfred A. Knopf, 1940.

The Old Beauty and Others. New York: Alfred A. Knopf, 1948.

On Writing: Critical Studies on Writing as an Art. New York: Alfred A. Knopf, 1949.

Willa Cather's Collected Short Fiction, 1892–1912. Lincoln: University of Nebraska Press, 1965.

The Kingdom of Art: Willa Cather's First Principles and Critical Statements, 1893–1896. Edited by Bernice Slote. Lincoln: University of Nebraska Press, 1967.

The World and the Parish: Willa Cather's Articles and Reviews, 1893–1902. Edited by William Curtin. 2 vols. Lincoln: University of Nebraska Press, 1970.

Uncle Valentine and Other Stories: Willa Cather's Collected Short Fiction, 1915–1929. Edited by Bernice Slote. Lincoln: University of Nebraska Press, 1973.

Willa Cather in Person: Interviews, Speeches, and Letters. Edited by L. Brent Bohlke. Lincoln: University of Nebraska Press, 1986.

Collected Stories. New York: Vintage Classics, 1992.

Stories, Poems, and Other Writings. New York: Library of America, 1992.

The Selected Letters of Willa Cather. Edited by Andrew Jewell and Janis Stout. New York: Alfred A. Knopf, 2013.

BIOGRAPHICAL AND CRITICAL WORKS

Acocella, Joan. *Willa Cather and the Politics of Criticism.* Lincoln: University of Nebraska Press, 2000.

Bogan, Louise. "American Classic." *The New Yorker,* August 8, 1931.

Brown, E. K. *Willa Cather: A Critical Biography.* New York: Alfred A. Knopf, 1953.

Daiches, David. *Willa Cather: An Introduction.* Ithaca, NY: Cornell University Press, 1951.

Gornick, Vivian. "Willa Cather." In *The End of the Novel of Love,* 85–102. Boston: Beacon Press, 1997.

Lee, Hermione. *Willa Cather: Double Lives.* New York: Pantheon Books, 1989.

Lewis, Edith. *Willa Cather Living: A Personal Record.* New York: Alfred A. Knopf, 1953.

Lindemann, Marilee. *Willa Cather: Queering America.* New York: Columbia University Press, 1999.

McClure, S. S. *My Autobiography.* New York: Magazine Publishers, 1914.

Mencken, H. L. *H. L. Mencken on American Literature.* Athens: Ohio University Press, 2002.

Milmine, Georgine. *The Life of Mary Baker G. Eddy and the History of Christian Science.* Grand Rapids, MI: Baker Book House, 1971; originally published 1909.

Morrison, Toni. *Playing in the Dark: Whiteness and the Literary Imagination.* New York: Vintage Books, 1993.

Munro, Alice. "Dulse." In *The Moons of Jupiter*, 36–59. New York: Alfred A. Knopf, 1983.

O'Brien, Sharon. *Willa Cather: The Emerging Voice*. Cambridge, MA: Harvard University Press, 1986.

Porter, Katherine Anne. "Reflections on Willa Cather." In *The Collected Essays*, 20–46. New York: Delacorte Press, 1970.

Randall, John H., III. *The Landscape and the Looking Glass: Willa Cather's Search for Value*. Boston: Houghton Mifflin, 1960.

Rose, Phyllis. "Modernism: The Case of Willa Cather." In *Modernism Reconsidered*, edited by Robert Kiely, 123–45. Cambridge, MA: Harvard University Press, 1983.

Rosowski, Susan. *Willa Cather's Ecological Imagination*. Lincoln: University of Nebraska Press, 2003.

Ross, Alex. "Brünnhilde's Rock: Willa Cather and the Singer-Novel." In *Wagnerism: Art and Politics in the Shadow of Music*, 323–54. New York: Farrar, Straus and Giroux, 2020.

Sergeant, Elizabeth Shepley. *Willa Cather: A Memoir*. Philadelphia: Lippincott, 1953.

Stout, Janis P. *Willa Cather: The Writer and Her World*. Charlottesville: University Press of Virginia, 2000.

Van Ghent, Dorothy Bendon. *Willa Cather*. Minneapolis: University of Minnesota Press, 1964.

Welty, Eudora. "The House of Willa Cather." In *The Eye of the Story: Selected Essays and Reviews*, 41–60. New York: Random House, 1979.

Woodress, James. *Willa Cather: A Literary Life*. Lincoln: University of Nebraska Press, 1987.

Image Credits

Insert page 1: PHO-277-045. Elizabeth A. Shannon Collection. Willa Cather Foundation Collections and Archives at the National Willa Cather Center in Red Cloud, Nebraska.

Page 2 (*top*): PHO-4-W689-111. Willa Cather Pioneer Memorial Collection. Willa Cather Foundation Collections and Archives at the National Willa Cather Center in Red Cloud, Nebraska; (*bottom*): PH0-4-W689-69. Willa Cather Pioneer Memorial Collection. Willa Cather Foundation Collections and Archives at the National Willa Cather Center in Red Cloud, Nebraska.

Page 3 (*top*): PH0-4-W689-59. Willa Cather Pioneer Memorial Collection. Willa Cather Foundation Collections and Archives at the National Willa Cather Center in Red Cloud, Nebraska; (*bottom*): PHO-4-W689-51. Willa Cather Pioneer Memorial Collection. Willa Cather Foundation Collections and Archives at the National Willa Cather Center in Red Cloud, Nebraska.

Page 4 (*top*): PHO-50-1094. Southwick Family Collection. Willa Cather Foundation Collections and Archives at the National Willa Cather Center in Red Cloud, Nebraska; (*bottom*): Archives and Special Collections. University of Nebraska–Lincoln Libraries.

Page 5 (*top*): PHO-4-W689-42. Willa Cather Pioneer Memorial Collection. Willa Cather Foundation Collections and Archives at the National Willa Cather Center in Red Cloud, Nebraska; (*bottom*): PHO-231-050. Lindgren Family Collection. Willa Cather Foundation Collections and Archives at the National Willa Cather Center in Red Cloud, Nebraska.

Page 6 (*top*): PHO-4-W689-128. Willa Cather Pioneer Memorial Collection. Willa Cather Foundation Collections and Archives at the National Willa Cather Center in Red Cloud, Nebraska; (*bottom*): PHO-277-043. Elizabeth A. Shannon Collection. Willa Cather Foundation Collections and Archives at the National Willa Cather Center in Red Cloud, Nebraska.

Page 7 (*top*): Archives and Special Collections. University of Nebraska–Lincoln Libraries; (*bottom*): PHO-255-001. Father Pacificus Kennedy Collection. Willa Cather Foundation Collections and Archives at the National Willa Cather Center in Red Cloud, Nebraska.

Page 8 (*top*): PHO-4-W689-144. Willa Cather Pioneer Memorial Collection. Willa Cather Foundation Collections and Archives at the National Willa Cather Center in Red Cloud, Nebraska; (*bottom*): PHO-4-W689-203. Willa Cather Pioneer Memorial Collection. Willa Cather Foundation Collections and Archives at the National Willa Cather Center in Red Cloud, Nebraska.

Index

INDEX

INDEX

Ten

Things Unguessed At
and Unforeseeable

———◆———

Nineteen twenty-seven would be a year of trials as well as triumphs. That summer Charles Cather, Willa's father, suffered a severe attack of angina, the harbinger of worse to come. Willa cut short a stay in the Bighorn Mountains of Wyoming in order to be with him at Red Cloud. Back in New York, she and Edith faced the loss of their cherished apartment on Bank Street. The IND had been cutting through a new subway line nearby, making the neighborhood much less pleasant. Then it was announced that No. 5 Bank Street and

two other brownstones were to be pulled down to make way for an apartment building (the same that can be seen on the corner of Bank and West Eleventh today). Willa and Edith moved to the Grosvenor Hotel at 35 Fifth Avenue, opposite the Church of the Ascension. Intended as temporary, this makeshift would last five cramped and uncomfortable years, and be Willa's inducement for spending less time in New York in favor of Jaffrey, Grand Manan, Quebec, and Paris; also in Red Cloud, where Mr. Cather's situation was worsening. That Willa chose to remain in New York at all was surely owing to Edith's position at J. Walter Thompson. Still, they were frequently apart in these years, particularly as Edith never accompanied Willa to Red Cloud. Would the connubial nature of their attachment have been too obvious if she had? Probably.

Mr. Cather died of a heart attack on March third. Willa caught the next train out of New York for the funeral and stayed on for several weeks. One of her foremost stories, "Neighbour Rosicky," germinated from this grief. In it, a Bohemian farmer who has lived well makes his arrangements with death—makes friends, as Freud would say, with the necessity of dying. He is a man at home in his skin who looks forward without fear to the change that nature must imminently make. He is the husband of a good woman, the father of fine children. The Rosickys are a family who haven't much beyond what they need, but are clearly possessed of the secret